IMAGES
of America

THOMAS EDISON
IN WEST ORANGE

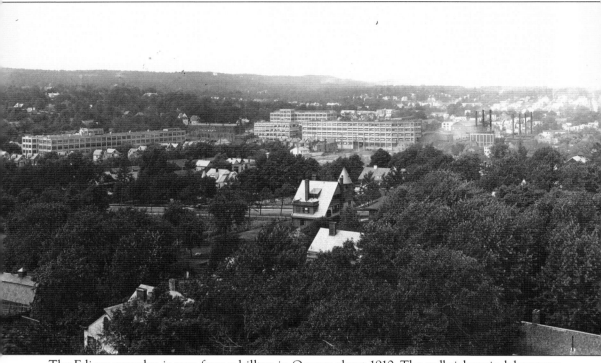

The Edison complex is seen from a hilltop in Orange about 1910. The redbrick main laboratory building, dating from 1887, is slightly left of center, almost dwarfed by the factory buildings that surround it, a storage battery factory to the left, an administration building, and several phonograph factories to the right. The lush greenery of Llewellyn Park, the private residential community where Thomas Edison lived, is at the upper left.

On the cover: Edison is seated at his desk in the library of Building 5, ready to receive his guests. By the time of this photograph, in November 1911, many awards and honors filled the walls. The room was designed to impress visitors, journalists, and potential investors. An Ediphone, a phonograph for office dictation, is at the left. (Courtesy Edison National Historic Site.)

IMAGES
of America

THOMAS EDISON IN WEST ORANGE

Edward Wirth

ARCADIA
PUBLISHING

Copyright © 2008 by Edward Wirth
ISBN 978-0-7385-5721-2

Published by Arcadia Publishing
Charleston SC, Chicago IL, Portsmouth NH, San Francisco CA

Printed in the United States of America

Library of Congress Catalog Card Number: 2007941111

For all general information contact Arcadia Publishing at:
Telephone 843-853-2070
Fax 843-853-0044
E-mail sales@arcadiapublishing.com
For customer service and orders:
Toll-Free 1-888-313-2665

Visit us on the Internet at www.arcadiapublishing.com

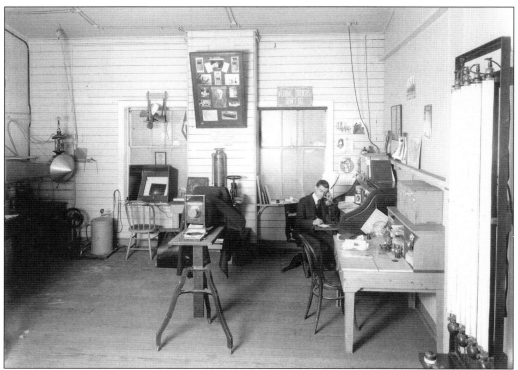

This is the photograph service department on the third floor of Building 5 as it appeared in January 1917. Staff photographers captured everything from factory construction to experiments and assembly line operations. They contributed to the instruction manuals, catalogs, and promotional literature published by the many Edison companies. Their work now forms the Historical Photograph Collection at Edison National Historic Site and is the source of most of the images in this book.

Contents

ACKNOWLEDGMENTS

For the past several years, the archives staff at Edison National Historic Site has been organizing the extensive documentary record left by Thomas Edison and his associates. The finding aids prepared by Kathy Bryan, Robert W. Engel, James Fox, Alan Ginsberg, Marilyn Gisser, Steven Higgins, Émilie J. Dupont, Rebecca Johnson, Madeline Rogers, Gregory F. Schmidl, Douglas Sterling, Curt Vogt, and Mary Wilson have helped me immensely in compiling this book. My fellow archivist Leonard DeGraaf and Gerald Fabris, sound recordings curator at Edison National Historic Site, reviewed the text for accuracy, and Thomas E. Jeffrey of the *Thomas A. Edison Papers* also provided valuable information. All photographs, except those so indicated, are from the archives of Edison National Historic Site. The books listed in the bibliography explain more fully the complexities of Edison's life, inventions, and business practices that can only be sketched here.

INTRODUCTION

By the time he moved to West Orange in 1887, Thomas Edison was already famous. He had improved Morse's telegraph and Bell's telephone and had invented the phonograph, a practical incandescent lamp, and an electric distribution system. He was the "Wizard of Menlo Park," but it was at West Orange that he built a phonograph business, developed motion pictures, invented a successful nickel-iron-alkaline storage battery, and manufactured a variety of other products. Edison's new laboratory eventually employed a staff of over 100 "muckers," experimenters who worked on a variety of projects. As their experiments yielded commercial products, Edison surrounded the laboratory with more than 20 factory buildings employing thousands of workers.

The new laboratory was 10 times the size of its predecessor in Menlo Park. The main building, three stories high, included a library where experimenters began their research. A heavy machine shop on the first floor and a precision machine shop on the second floor turned out models and prototypes. Experimental rooms honeycombed the rest of the building, and their movable walls shrank or enlarged the rooms as needed. The goal, as Edison wrote in one of his notebooks, was "the best equipped and largest laboratory extant and the facilities superior to any other for rapid and cheap development of an invention." He boasted that he hoped to turn out "a minor invention every 10 days and a big thing every six months or so."

The main building could not contain everything Edison wanted, so he constructed four more at right angles to the main building. Building 1 was dedicated to electrical experiments, Building 2 was a chemistry laboratory, Building 3 housed a woodworking shop and storage space for chemical supplies, and Building 4 was a metallurgical laboratory. Building 1 faced Valley Road (now Main Street) parallel to the end of the large building, which became Building 5; an arch between the two made a formal entrance to the complex. A large open space between Buildings 1 and 2 created a courtyard where workers could meet, have lunch, and talk about their projects.

Meeting space was important. Edison and his colleagues brought with them the traditions of shop culture, a way of life common for centuries in the workshops of Europe that was seeing its last flowering in 19th-century America. "Shop culture" describes the practices of a group of skilled craftsmen who worked together under the supervision of a leader. Each had a principal assignment, but all were free to contribute to any part of the project. Occasionally they simply killed time, by smoking, playing cards, and sharing food and, yes, drink; they would then return to their projects and toil away, perhaps late into the night.

The grand scale of this new laboratory meant that Edison could pursue many projects at once and even lease space to other inventors. He planned to pay his bills, at least initially, by conducting research for the emerging electric power companies that he had helped bring into existence.

Although Edison earned over half of his 1,093 patents at West Orange, he had little faith in the patent system, which often resulted in lawsuits and adverse court decisions. He preferred to keep his inventions secret, form a company, and build a factory to manufacture a product. Sales would generate income to repay investors and finance new experiments.

Factories mushroomed around the laboratory. By the early 1900s, sales of phonographs, sound recordings, motion picture machinery, and films were so successful that dozens of office workers were hired to manage the paperwork of the increasingly complex business. A new building devoted exclusively to administration went up in 1906.

This increase in white-collar workers reflected the changing face of business in America. Assembly line practice required the specialization of workers, each assigned to a single task along the line. Shop culture was dying out; muckers enjoyed less freedom and submitted to more control. No longer could they move from project to project, nor could they waste time. The flexible features of shop culture, such as sitting and thinking, doodling and tinkering, could not be measured or analyzed and did not conform to the time clock. Power passed from the independent craftsmen and muckers of the early days (many of whom had moved on, retired, or died) to the managers who were committed to cutting costs.

The business success of the early 1900s turned to slump by 1910. Sales were down, and Edison's practice of moving from idea to product to company to factory had produced a hodgepodge of businesses, some successful, others not. Edison borrowed from one to pay the debts of others or covered losses from his own pocket. In 1911, he consolidated many of his companies under the umbrella name of Thomas A. Edison, Incorporated (TAE, Inc.) to control costs and to centralize common operations such as advertising, purchasing, and legal services.

On December 9, 1914, a devastating fire destroyed almost half the factory buildings, but Edison immediately set out to rebuild with as little interruption as possible. Within three months, several product lines were back in production. The next year, Edison announced a divisional plan that transformed many of the previously independent companies into divisions of TAE, Inc.

Immediately after the First World War, phonographs and recordings enjoyed huge sales, since they had been largely unavailable during wartime. By 1920, however, sales plummeted, and throughout the decade, managers could still not reduce costs. This was in part Edison's fault; he constantly refined existing products so that few were ever truly "finished." Engineers often waited in vain to draw the final blueprints for products and the machine tools to make them. Edison also continued making some products he should have discontinued earlier, and he clung stubbornly to outdated models instead of adopting the improvements introduced by his competitors. Just as he retreated from the electrical business in the 1890s, he ceased making motion picture equipment in 1918 and entertainment phonographs in 1929. But even following Edison's death in 1931, the company and its successors continued manufacturing storage batteries and office dictation phonographs into the 1960s.

Alfred Tate, one of Edison's first secretaries, suggested that Edison might have accomplished more if he had tried less; the ability to pursue any and all projects in a lavishly equipped laboratory encouraged him to start new campaigns before others were completed. Indeed, the introduction of a new product often came only in response to the pressure of a competitor nipping at Edison's heels.

On the other hand, business giants praised some of his practices. Henry Ford, an early admirer who became a friend, said he learned the principles of assembly line manufacture from observing the conveyor belts of an Edison ore milling plant in Ogdensburg, New Jersey, and not the meatpacking plants of Chicago. Alfred Sloan sent his managers to West Orange to study Edison's divisional plan for TAE, Inc., before he undertook the reorganization of General Motors.

His astonishing contributions to light, sound, power, and film notwithstanding, perhaps Edison's greatest invention was the modern research and development laboratory linked directly to a professionally managed diversified business.

One

GETTING TO
WEST ORANGE

Thomas Alva Edison was born in Milan, Ohio, on February 11, 1847, and by the time he was seven, the family had moved to Port Huron, Michigan. With only a few months of formal education (he was taught at home for a while by his mother), the adolescent Edison began working as a candy butcher on the Grand Trunk Railroad that ran through Port Huron to Detroit. He learned Morse code and telegraphy from a local stationmaster and published his own newspaper on the train, often using the telegraph traffic he picked up along the route to update his paper on the fly. Later he worked as an itinerant telegrapher throughout the Midwest and upper South.

Edison had a talent for improving telegraphic equipment and eventually settled in Boston, where he worked for Western Union. He later moved to New York City and set up several workshops with a series of partners; the last was located in Newark, New Jersey. On Christmas Day of 1871, he married Mary Stilwell, a young woman who worked in the shop; they would eventually have a daughter and two sons. In 1876, he bought land in Menlo Park, New Jersey, and built a larger laboratory and workshop there. The location was ideal; at a distance of about 20 miles from New York City, it was far enough to provide seclusion for himself and his staff, yet near enough to attract reporters and financial backers when needed. At Menlo Park, Edison invented the phonograph and developed a practical incandescent lamp as well as the electrical power system required to illuminate it.

Edison left Menlo Park for New York City in 1881 to supervise the installation of his electric lighting system. Mary died in 1884. A widower with three children, he married his second wife, Mina Miller, in 1886 and bought a home for her in West Orange, New Jersey, about 10 miles from Manhattan. There he built his last laboratory.

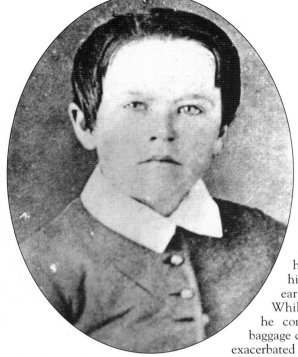

These are among the few existing photographs of Thomas Edison as a child. The one at left shows him at the age of 10; the more confident boy in the jaunty cap is Edison at age 14. The young Edison was known as Alva or Al. He was a sickly child and may have had a congenital condition that affected his hearing, rendering him deaf in his left ear and with reduced hearing in his right. While working on the Grand Trunk Railroad, he conducted chemical experiments in the baggage car. An explosion on the train may have exacerbated his hearing loss.

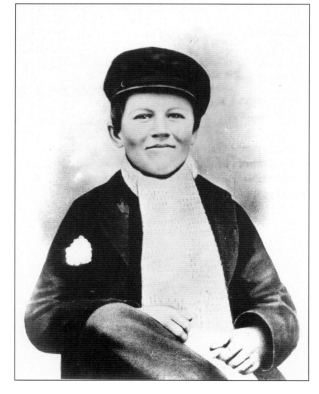

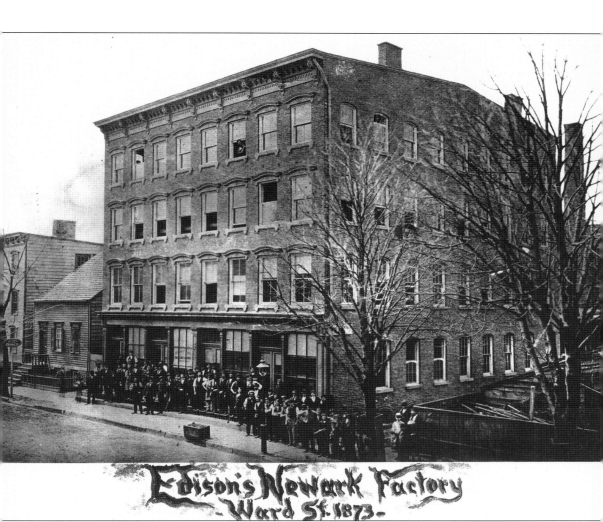

Edison's Newark Factory
- Ward St. 1873 -

Edison set up a series of small companies with a string of partners. From 1871 to 1876, he and his staff occupied this building at 10–12 Ward Street in Newark under constantly changing company names. Here he worked on multiplex telegraphy (messages moving in opposite directions simultaneously along the same wire) and the electric pen and autographic press, predecessors to the mimeograph.

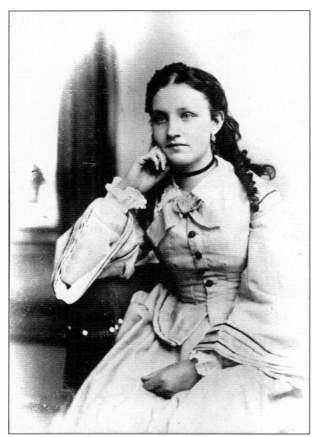

Mary Stilwell worked in the Ward Street office. She married Thomas Edison in 1871 (the year of the photograph at left) when she was 16 and he was 24. Their daughter Marion Estelle was born in February 1873, followed by sons Thomas Alva Jr. in January 1876 and William Leslie in October 1878. The high cost of working in Newark contributed to Edison's decision to move to Menlo Park. Below is Edison's laboratory, photographed around 1878. It had a small library, an office, and a machine shop on the first floor and a laboratory on the second floor.

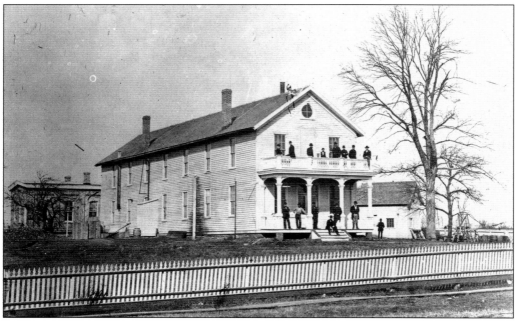

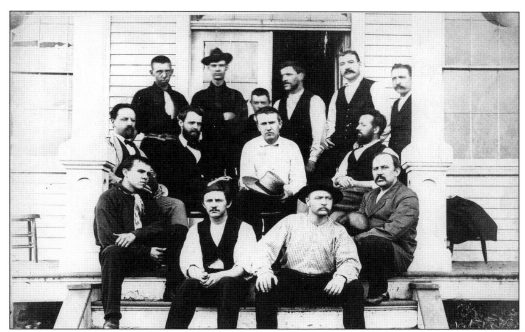

Edison and his staff pose on the porch of the Menlo Park laboratory. Seen here from left to right are (first row) Francis Jehl, Martin Force, Alfred Swanson, and Stockton L. Griffin (Edison's first secretary); (second row) Dr. A. E. Haid, Francis R. Upton, Edison, and Charles Batchelor; (third row) James Seymour, James Lawson, John F. Randolph, George Carman, Maj. Frank McLaughlin, and John F. Ott. Upton, a mathematician, and Batchelor, a mechanic, were among Edison's closest associates in the early years.

The Edison home in Menlo Park was a short distance from the laboratory. Thomas and Mary, their three children, and Mary's sister Alice all lived there along with three servants. Mary's brother Charles moved to Menlo Park to work in the laboratory, and he may have joined the household too.

Sarah Jordan, second from left, and some of her guests gather on the porch of her boardinghouse in 1879, where several of the unmarried men lived. Thomas Edison, in shirtsleeves with arms crossed, stands by the right window. His sister-in-law Alice Stilwell is in the window.

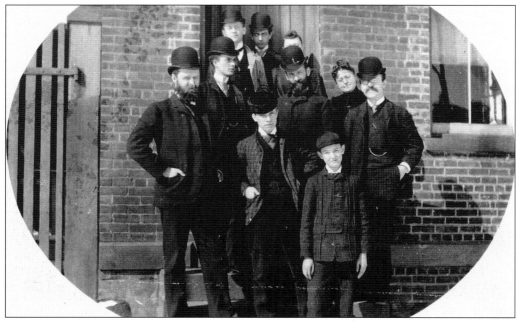

Edison set up a lamp factory in Harrison, New Jersey, near Newark, to make electric bulbs. These are employees of the decorative and miniature lamp department about 1889. Francis Upton is at the left, and William H. Meadowcroft, who would become Edison's last personal secretary, is at the right.

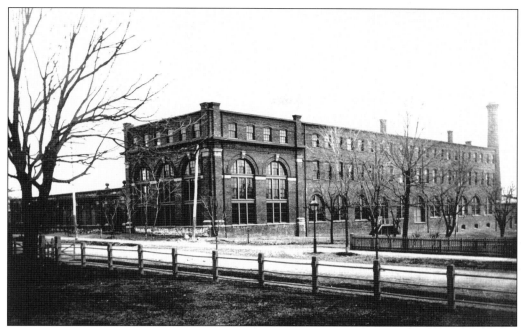

This is the main building of the West Orange laboratory shortly after it was built in 1887 at the corner of Main Street and Lakeside Avenue. Already the nation's foremost inventor, Edison wanted to maintain that position by building a distinguished laboratory. His original drawings featured a building with a tower and a mansard roof; his architect designed this building, less grandiose but still impressive.

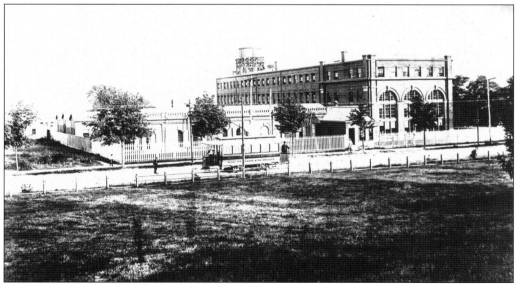

This view shows the large building (Building 5) in relation to its smaller neighbors. Like the Menlo Park laboratory, Building 5 housed Edison's office and library, machine shops, and experimental rooms, but on a much grander scale. The single-story Buildings 1–4 can be seen at the left, with the earliest Phonograph Works buildings in the distance behind them. This photograph dates from about 1890.

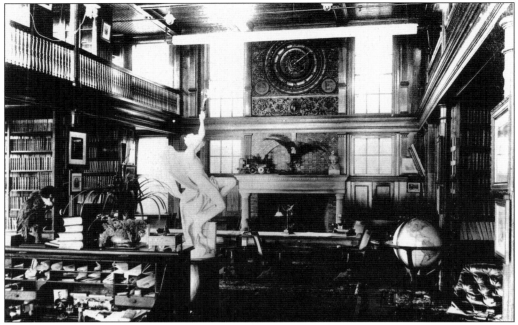

Thomas Edison used his library as an office and wanted it to impress everyone who entered. The three tiers of shelving housed patent materials, scientific and technological journals, trade publications, and reference books. Experimenters began their projects here, researching what others had already done in a particular field. Edison's desk is at the left. He bought the statue *Genius of Electricity* in Paris in 1889, about six years before this photograph.

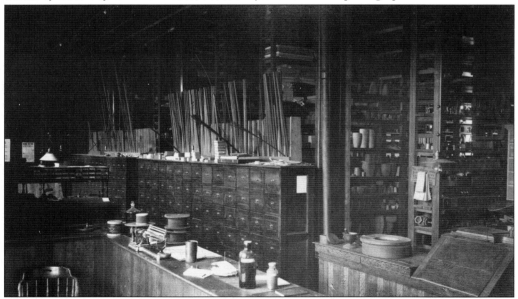

The stockroom, here in 1890, extended from just outside the library to the heavy machine shop. Edison believed in having on hand all the supplies his workers might need, and dealers provided him with exotic materials from around the world. He once said that his stockroom would be equipped with "everything from an elephant's hide to the eyeballs of a Senator."

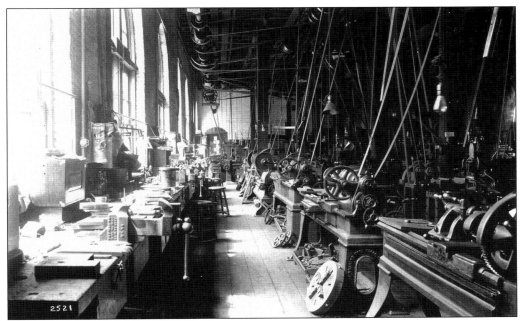

The heavy machine shop was perhaps the noisiest part of Building 5. These images date from April 1914. Skilled workers made models using the lathes seen in the picture above, plus drill presses and reamers elsewhere in the room. Another row of machine tools lined the opposite side of the room. Each was powered by one of two driveshafts that ran the length of the room, just below the ceiling. A worker would shift a belt attached to his machine from a neutral position onto the rotating driveshaft, thus drawing down power to his machine. Two motors at the rear of the room powered the shafts themselves. The image below shows the other side of the room, including the foreman's desk, from which he supervised the various projects. The stockroom is just beyond the brick wall at right.

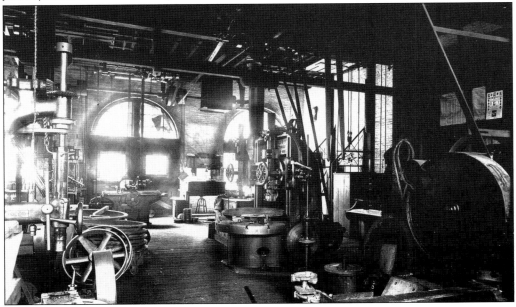

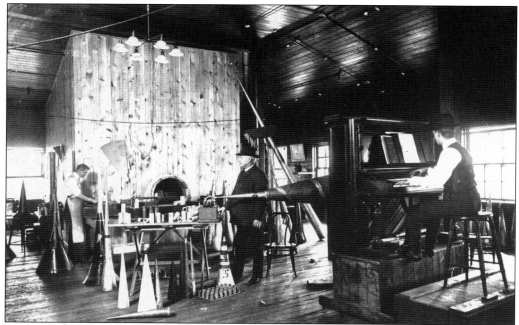

The Music Room was located on the third floor above the library; the two-story volume of the library provided the Music Room with good acoustics. From left to right, Albert Kiffer, Theodore Wangemann, and George Boehme are making some recordings, about 1905. Wangemann was a gifted pianist himself and was responsible for producing some of the earliest experimental recordings in this room in the 1880s and 1890s.

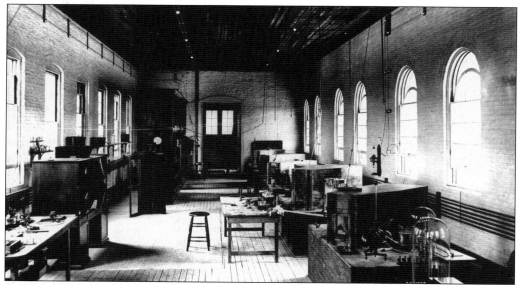

Building 1 was designed for electrical experiments and became known as the galvanometer room. The worktables along the right, each measuring about four feet by eight feet, had brick foundations to minimize vibrations and provide stability for delicate instruments. Edison left the electrical business in the 1890s, when this photograph was taken. By the 1920s, this building housed accountants and other office workers.

The chemistry laboratory was always filled with a variety of projects. The men in this 1910 photograph are working on nonflammable motion picture film, a lithium storage battery, and new materials for sound recordings.

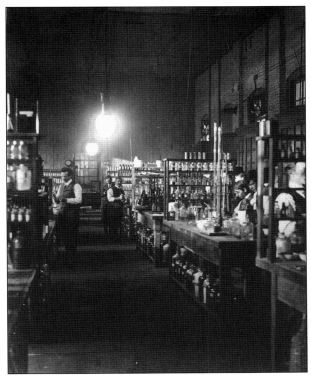

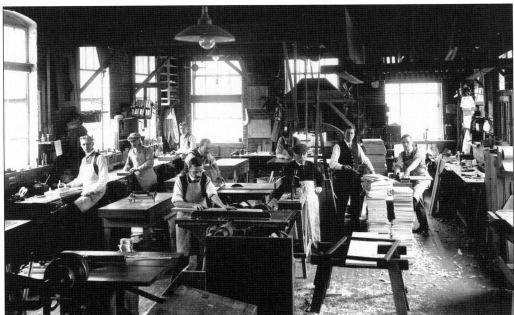

In the Building 3 pattern shop, carpenters made wooden models of parts that would later be cast in metal. The driveshaft that ran these tools was in the basement. The belt that powered the saw in the foreground is concealed in the box next to it. Hiding the belting prevented accidents; a carpenter with a piece of lumber would not want to become entangled in a dozen belts.

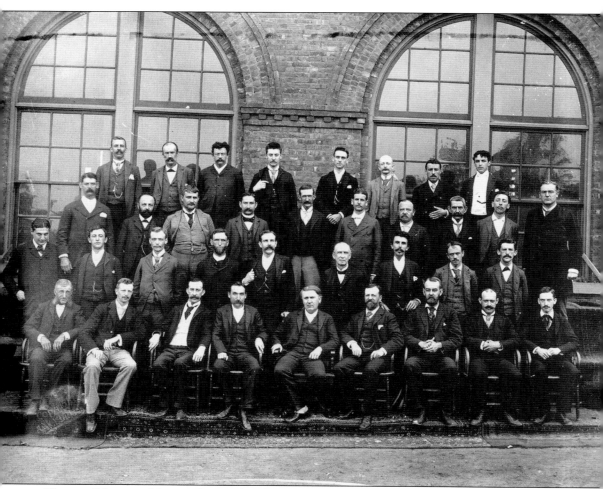

Thomas Edison and his muckers gather for a formal portrait in the courtyard in 1893. Charles Batchelor and Walter Mallory are to the right of Edison; W. K. L. Dickson stands between them in the row behind. John Ott sits to the left of Edison; his brother Fred stands two rows behind him. Walter Miller, manager of phonograph recording, is second from the left in the second row; Jonas Aylsworth, chemist, stands to the right of Miller. These were the men who worked with Edison to make a technological revolution.

Two

HIS FAVORITE INVENTION

Edison often called the phonograph his favorite invention, and the phonograph business, with its successes and failures, was the cornerstone of the West Orange enterprise. The idea of recording sound occurred to Edison during his telephone experiments, when he sought a way to record telephone messages. In 1877, his machinists built a cylindrical prototype that worked, and he demonstrated it at the offices of *Scientific American*. Fairly well known in the esoteric telegraph and telephone industries, Edison became instantly famous with the phonograph. Everyone could marvel at a machine that reproduced the human voice. After a flurry of publicity, however, he neglected the device for a decade as he devoted his energies to electric lighting systems.

During those years, several competitors developed their own sound reproduction machines that captured the public's attention. Determined to regain ascendancy in a field that he had, after all, invented, Edison "perfected" his phonograph by improving the mechanics and the casing after the move to West Orange. By the late 1890s, he was selling phonographs and prerecorded cylinders through a network of middlemen. Cylinders eventually lost favor to discs, introduced by Emile Berliner, and by 1912, Edison had added a line of his own discs and players.

With the introduction of the Diamond Disc phonograph, Edison took an active interest in the artists and songs recorded by his company. Despite his poor hearing, he auditioned musicians and singers and reviewed recordings before their release. Because he cared more for the technical quality of his recordings, he preferred certain types of voices, music, and instruments and ignored many of the artists the public liked and who were eagerly hired by companies like Columbia and Victor. He also failed to adopt technical innovations that made competitors' machines more popular.

By the late 1920s, Edison was losing ground, and he scrambled to maintain a share of the market by manufacturing radio-phonograph combinations. It was not to be; in 1929, Edison discontinued his entertainment phonograph business, although the Edison business phonograph for office dictation and transcription, known successively as the Ediphone and the Voicewriter, remained a popular product through the 1960s.

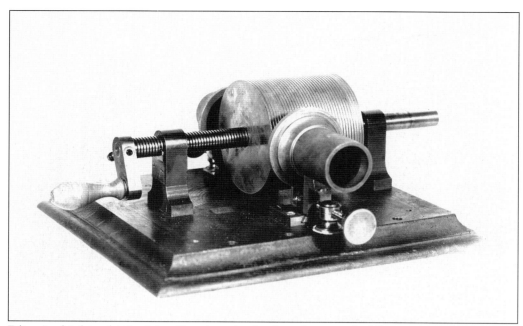

Edison's chief machinist John Kruesi made the first phonograph following an Edison sketch. Edison wrapped the cylinder with heavy tinfoil and shouted through a recording horn inserted in a port on the far side. The vibrations of his voice caused a stylus to make a continuous indentation on the foil. The reproducing horn was inserted in the port in front. All later models combined recording and playback in one port.

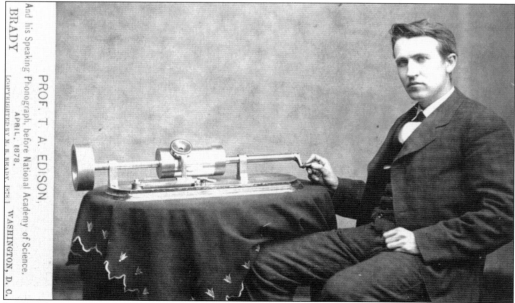

In April 1878, Thomas Edison took his phonograph from Menlo Park to Washington, D.C., to demonstrate the new marvel at the National Academy of Sciences and at the White House for Pres. Rutherford B. Hayes. He stopped at Mathew Brady's studio to have this photograph taken.

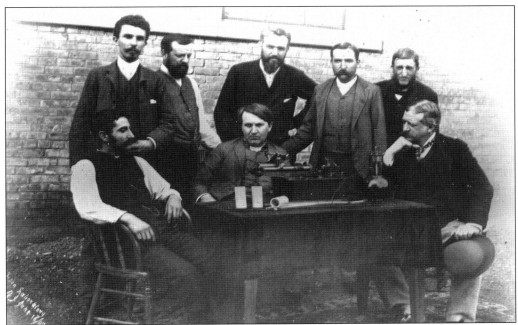

Edison and his colleagues improved the phonograph at West Orange. Here they gather in the courtyard on June 16, 1888, with the "perfected" phonograph after many hours of work. Seen here are, from left to right, (seated, first row) Fred Ott, Edison, and Col. George Gouraud, who was Edison's agent in England; (standing, second row) W. K. L. Dickson, Charles Batchelor, Theodore Wangemann, John Ott, and Charles Brown. Far from "perfect," a marketable phonograph took almost another decade to produce.

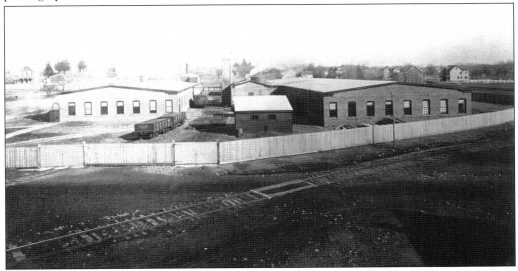

The Phonograph Works were the first to be added to the original laboratory. Built in 1888, these buildings housed a machine shop and assembly and testing rooms for phonographs, cylinders, and batteries. Improvements Edison made to the 1888 model included a stop/start mechanism and the replacement of tinfoil with wax cylinders for recording. The entire machine was placed in a wooden cabinet.

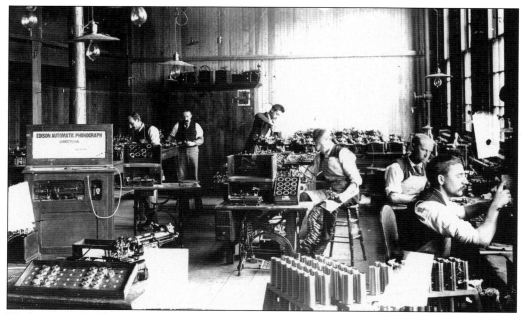

Workers are examining and packing cylinder recordings for the Edison Automatic Phonograph around 1890. The machine seen at the left was an early jukebox, a "coin-in-slot" phonograph that played a musical selection for a nickel. Customers listened through the ear tubes. Edison saw that the phonograph was becoming successful in bars, billiard halls, and other public places. The coin-in-slot machine was Thomas Edison's only successful phonograph in the early the 1890s.

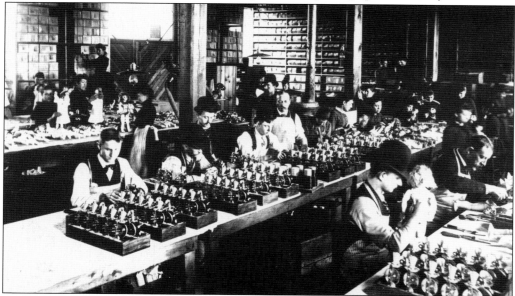

Workers here are busy assembling the Edison Talking Doll around 1890. At the left, women are attaching the imported porcelain heads to metal trunks equipped with wooden hands and feet. Men at the right are assembling the miniature phonograph "voice boxes." These delicate mechanisms frequently broke, however, and many dolls, their voices removed, were sold as ordinary toys.

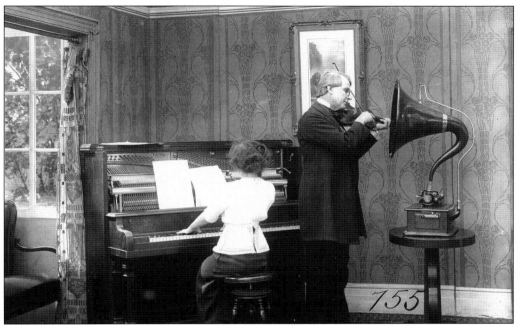

This pair is making a home recording around 1910. Edison marketed his phonographs in part by promoting the owner's ability to make new recordings at home, but the plan proved to be of limited success because the public preferred prerecorded songs, instrumentals, and comic monologues.

Edison adopted a single spring motor in 1897 for his cylinder phonographs. He lowered prices to compete with Columbia and introduced a range of models at several prices. These included the Home, Standard, Triumph, Gem, and Concert, among others. This advertisement from about 1912 shows a range of tabletop phonographs.

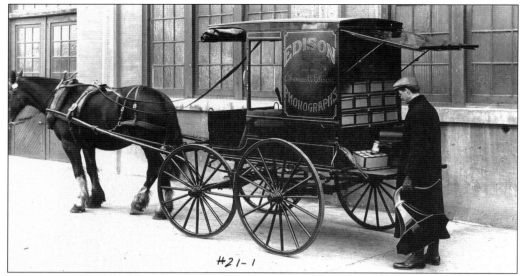

Thomas Edison first sold phonographs through the North American Phonograph Company to subcompanies that leased them to customers in particular territories. Later the National Phonograph Company (organized in 1896) sold through a network of jobbers and dealers (or wholesalers and retailers), thus allowing Edison to sell across a wider geographical area. This man and his cart are near one of the newer Phonograph Works buildings around 1912. Equipped with cylinders, machine, and horn, he is ready to call on customers in the neighborhood.

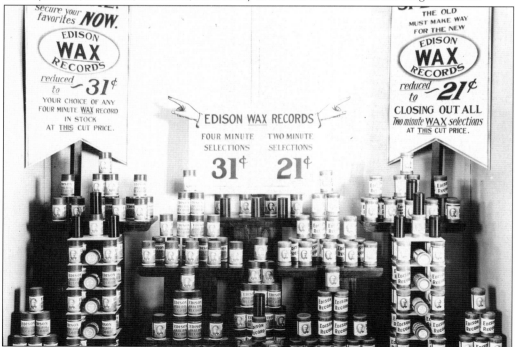

This store is clearing its shelves of black wax cylinder recordings. The sale anticipates the 1912 introduction of Blue Amberol recordings, made of a much more durable celluloid tube on a plaster core.

Edison introduced the Amberola phonograph in 1909 to compete with the Victrola; even the name is similar. The horn was no longer attached to the outside of the machine. Like the Victrola, the horn was now hidden behind a mesh grille, making the phonograph look like an attractive piece of furniture. This is an Amberola 75 model with storage space for cylinder recordings.

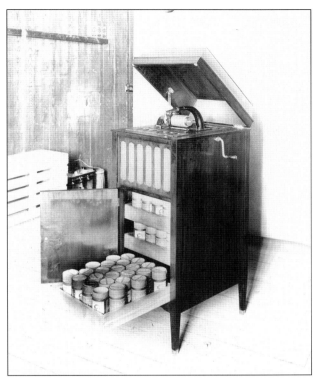

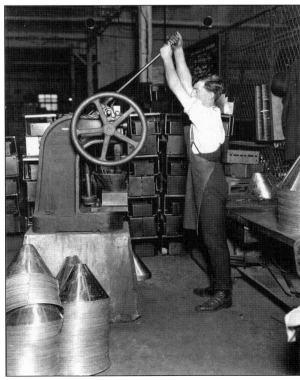

This man is pressing amplifying horns for Amberola phonographs around 1912.

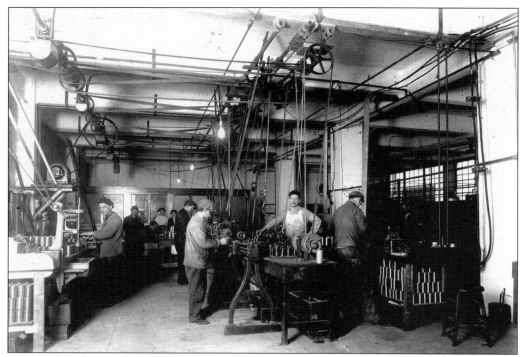

This is the Blue Amberol manufacturing department around 1912. Jonas Aylsworth, one of Thomas Edison's most talented chemists, developed a harder, virtually indestructible, celluloid cylinder. The Blue Amberol was the apex of cylinder recording technology. The lower image shows three advertising posters for Blue Amberols on display. The recordings sold well when first introduced, but the urban public's growing preference for disc records quickly relegated cylinders mostly to rural markets.

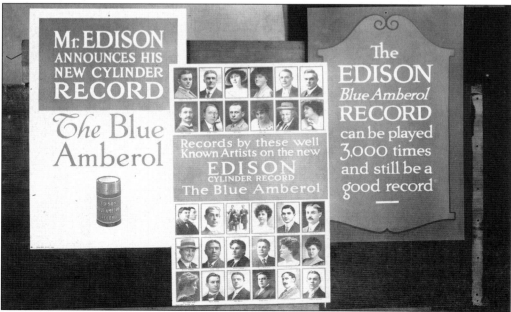

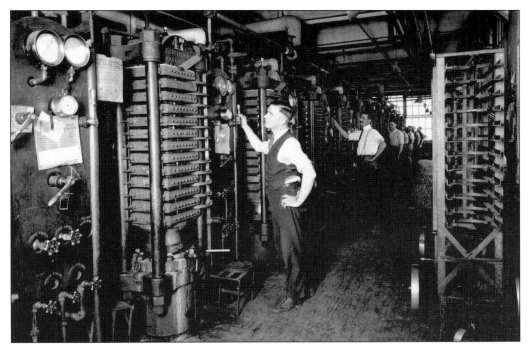

This is the disc pressing room. Sales of Victor discs began surpassing those of Edison's cylinders in 1909. Jonas Aylsworth, who had worked on recording research for years, developed Condensite, a harder plastic that was unsuitable for cylinder recordings but perfect for discs. Edison introduced the Diamond Disc phonograph in 1912, the same year as his Blue Amberol cylinder.

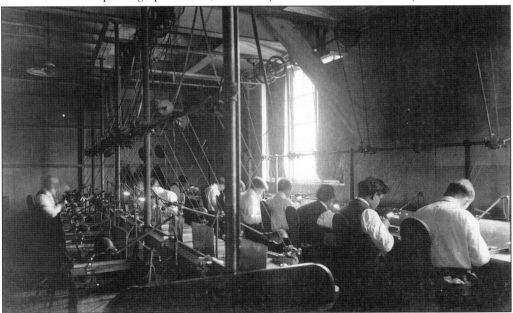

The diamond room is seen here about 1912. The new, harder disc recording would wear out the sapphire stylus Edison used, so he adopted diamonds and improved the reproducer that housed the stylus. Victor machines actually did use a needle, that is, a metal pin.

Miller Reese Hutchison, chief engineer of the laboratory, is seated at a table observing a team as they prepare a console phonograph for packing in the fall of 1912. Hutchison is writing instructions based on his observations. The presence of a camera on a tripod suggests that the instruction manual will include helpful illustrations.

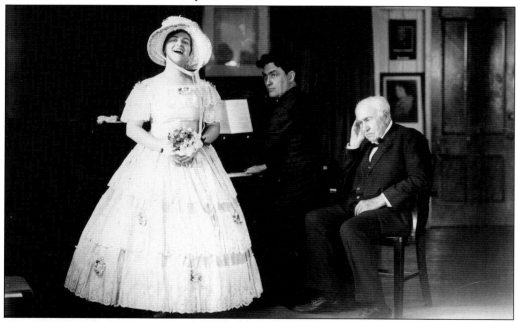

Thomas Edison listens to Helen Davis singing while Victor Young accompanies her at the piano about 1926. Edison took over the selection of music and artists in 1911, an unusual decision considering that he was partially deaf. His direct involvement with music selection contributed to the decline of record sales, because the public flocked to the more popular artists on competing labels.

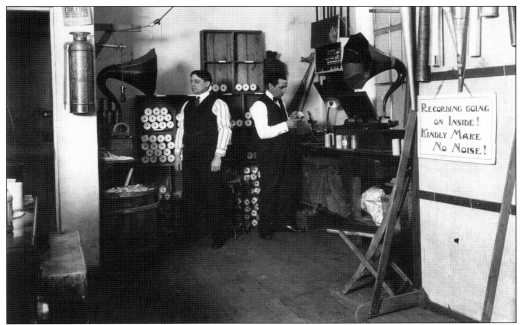

A recording session is in progress at the Columbia Street studio in West Orange, just a block away from the laboratory. George Werner (left) stands quietly, and Fred C. Burt examines a master wax cylinder. By this time (January 1917), most recording had moved to studios in New York City; the Columbia Street studio was used mainly for experimental recording.

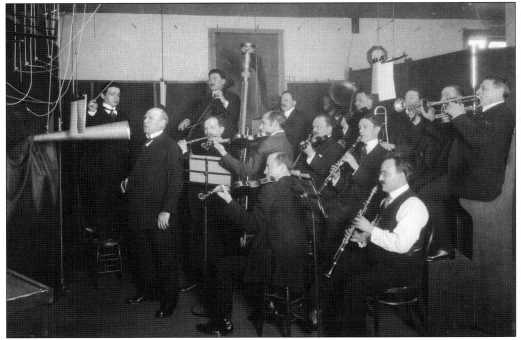

The New York City studios were more accessible to musicians. This March 1916 recording session is at 79 Fifth Avenue. The soloist is the Dutch tenor Jacques Urlus; Cesare Sodero conducts.

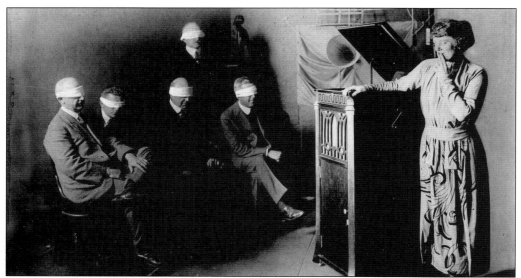

"Tone tests" were an advertising campaign to demonstrate the fidelity of Edison recordings. A musician sang or played along with a phonograph recording in the dark, and audiences were challenged to tell them apart. This 1918 photograph pokes fun at tone tests. The soprano Freida Hempel stands mischievously by a phonograph while blindfolded Edison officials, including Walter Miller (left), manager of the recording division, wait to pass judgment.

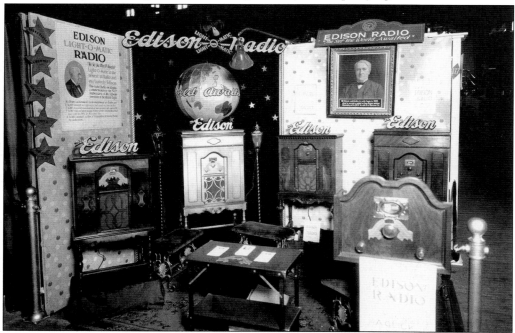

This St. Louis trade show display features the Edison Light-O-Matic Radio. Thomas Edison disliked radio, thinking that the quality of sound reproduction was inferior to his phonograph. But radio was becoming wildly popular by the mid-1920s, and Charles Edison urged his father to introduce a console combining radio and phonograph. After Edison discontinued phonograph manufacturing, the company continued marketing radio receivers for a time.

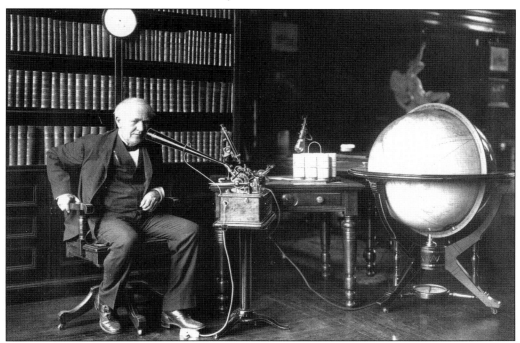

Edison poses in the library with his business phonograph in 1912. Although he thought that office dictation would be the chief use for the phonograph, the public quickly gravitated toward music. Edison never abandoned his plans for the office phonograph, however. This model was made for both dictation and transcription.

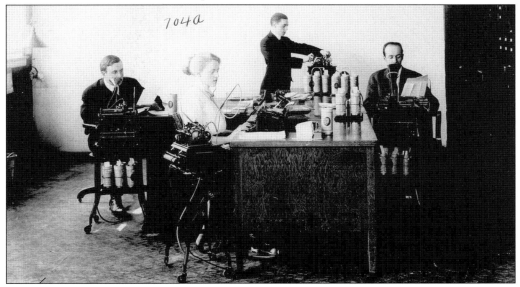

In this photograph from 1912, two "dictators," at left and right, are recording their letters on machines similar to the one Edison has in the top photograph. The "transcriber" in the foreground is listening to a recorded cylinder on a machine made exclusively for playback. The office boy at the rear is using a shaver to remove the topmost layer of a cylinder so that it can be reused. Together the three machines form a complete Edison office suite.

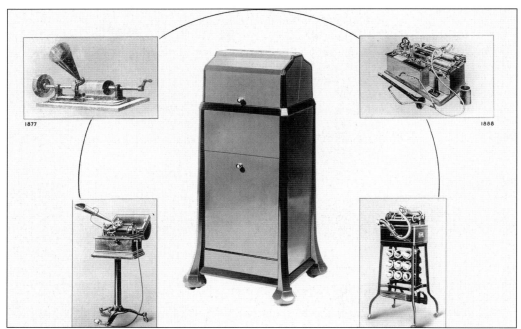

This advertising photograph shows the evolution of the business phonograph from the original tinfoil model of 1877 and wax cylinder phonograph of 1888 to the Edison business phonograph of 1905 and the Ediphone of 1921. The latest model, from about 1935, is at the center in its sleek metal cabinet.

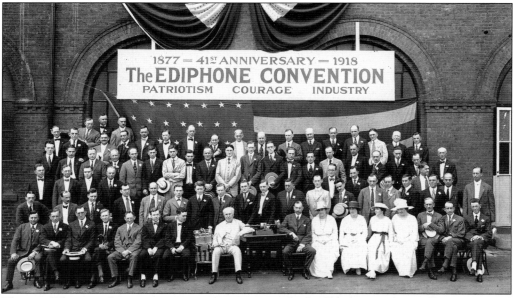

Thomas Edison took time every year to appear with the Ediphone sales staff at its annual convention. Salesmen faced the challenge of analyzing widely different office operations and tailoring the product to the needs of each business customer. Nelson C. Durand, head of Ediphone operations, sits across the table from Edison. The banner indicates that the nation is still at war.

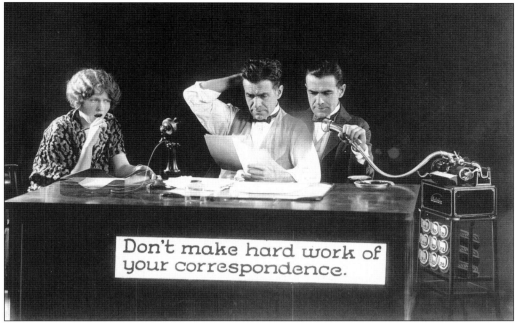

This photograph would form the basis of an Ediphone advertisement in the 1930s. The "ghost" image of the executive suggests that a business phonograph will help him to speed through his pending correspondence and save his secretary from boredom.

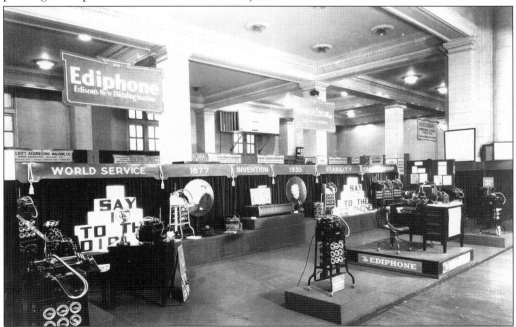

A selection of Ediphones is on display at a New York trade show in 1930. Through the 1920s and 1930s the emphasis was on making simpler, cheaper, and smaller machines that were easy to operate. The business phonograph was evolving from an exotic office "extra" to an office necessity.

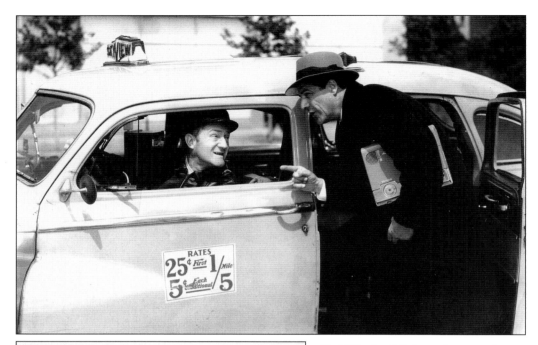

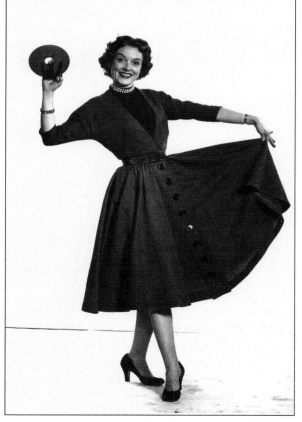

By 1951, the Ediphone became the Voicewriter, so portable the busy executive could tuck it under his arm as he ran for a taxi. The recording cylinder had been replaced by a plastic disc, proudly displayed by the secretary in the lower photograph. The Voicewriter division was eventually sold to Lanier Business Systems, which adopted cassette recording like other manufacturers of dictation machines in the 1960s and 1970s.

Three

MAKING PICTURES MOVE

Thomas Edison's meeting with the photographer Eadweard Muybridge in 1888 piqued his interest in the possibility of motion pictures. Muybridge's images of people and animals in motion came close to simulating movement itself. Edison submitted paperwork to the United States Patent Office that declared his intention to "devise an instrument that should do for the eye what the phonograph does for the ear." His staff photographer W. K. L. Dickson began building models while Edison departed for the Paris Exposition of 1889. Telegraph equipment provided an example; a strip of perforated film advanced through a camera was similar to a strip of perforated tape advanced through a telegraph. When Edison returned, he worked on the mechanics to operate Dickson's prototypes.

The first successful apparatus was a kinetograph, or camera for recording images, followed by a kinetoscope that displayed finished films. Edison envisioned film viewing as an individual practice, like his coin-in-slot phonograph. The kinetoscope would display a reel of film that a customer would watch through a viewer, like a peep show. Other innovators developed film projection for larger audiences, an idea Edison adopted later.

In the Black Maria, the first film studio, the kinetograph recorded simple movement: a sneeze, a kiss. Later films captured vaudeville acts, boxing matches, cockfights, exotic dancers. Over time, longer films that told a story, such as *The Great Train Robbery* (1903), took the public imagination. As early as 1901, operations moved to Manhattan and by 1907 to a larger studio in the Bronx.

Edison rarely involved himself with the artistic side of filmmaking, concentrating instead on technology and business. He explored several ideas that others eventually brought to fruition, such as sound films, color-tinted images, and home movies.

Edison's eventual exit from films can be attributed to several developments. The industry grew crowded and competitive; evolving public tastes rendered Edison films "old-fashioned"; the First World War closed lucrative European markets; and the new "movie star" phenomenon greatly increased production costs, as did wartime regulation and taxation. In 1918, Edison sold his motion picture business to the Lincoln and Parker Film Company, abandoning the industry that he had done so much to create.

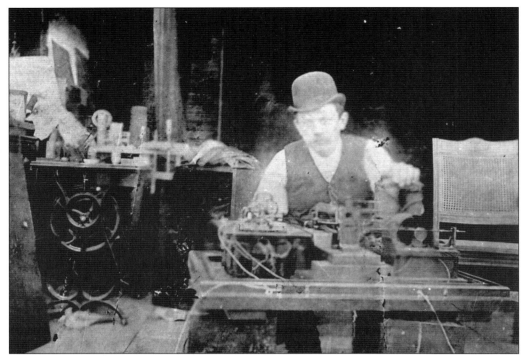

An early model by W. K. L. Dickson featured a drum wrapped with microscopic images that would be viewed through a microscope. Here Charles H. Kayser sits in a workroom with the first strip kinetograph, which pulled a strip of film horizontally through the apparatus. The film eventually used, 35 millimeters wide and perforated vertically, is still the standard today.

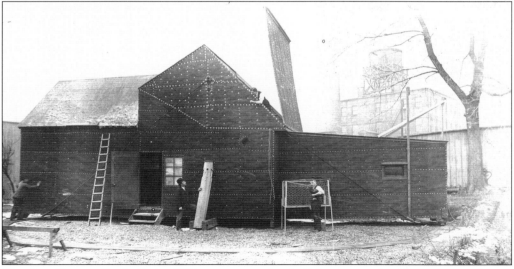

The first film studio, built in 1893, was a wooden building covered with tar paper. It was nicknamed the Black Maria (pronounced muh-RYE-uh), a slang term for a police wagon. The man at the far left is rotating the building on its track, allowing it to follow the sun, which entered through the open roof, bathing the stage in light. The bird at the right might be the star of a cockfight being filmed later.

These three strips of film, inserted through slits in a page of Charles Batchelor's notebook, may be among the earliest motion pictures ever made. The two on the left feature a boxing match, and in the third, Dickson waves a straw hat. The notations on the rest of the page concern ore milling experiments, demonstrating that laboratory notebooks were often crowded with information from several projects going on simultaneously.

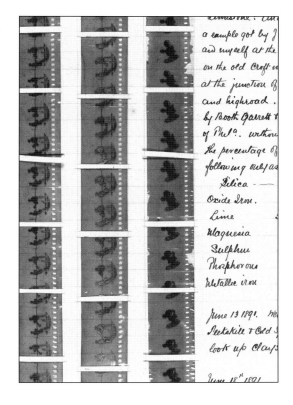

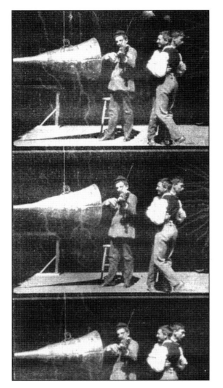

An early film made in the Black Maria featured Dickson playing his violin while two lab workers danced. Thomas Edison hoped from the beginning to make sound film, but it remained an elusive goal. He did introduce the kinetophone in 1913, a film projector synchronized with a phonograph. After some early publicity, the novelty wore off, and the kinetophone, its two halves often slipping out of synchronization, was withdrawn.

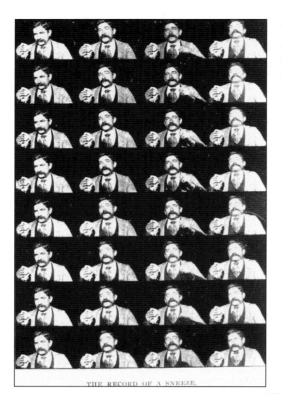

THE RECORD OF A SNEEZE.

The first copyrighted film was made in 1894, *Edison Kinetographic Record of a Sneeze*, featuring Fred Ott. That same year Edison copyrighted an additional 75 films.

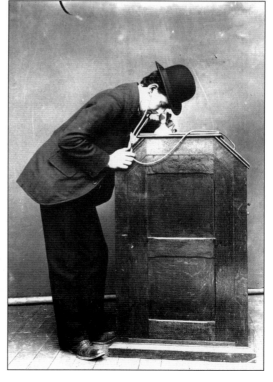

The man in this 1895 image is looking into a kinetoscope, which showed a brief film loop accompanied by an Edison cylinder recording as background music. Thomas Edison shipped several of these to an amusement parlor on 27th Street in New York City. His secretary Alfred Tate wrote that they caused a sensation and the parlor could not close until 1:00 the next morning.

Stripped of its ear tubes, this 1894 model stands open in the library to show the path the film took through the machine. The metal housing for the eyepiece can be seen protruding from the upturned lid at the top. This photograph is from 1939.

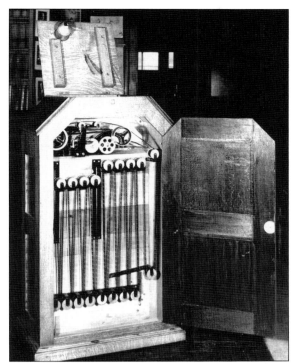

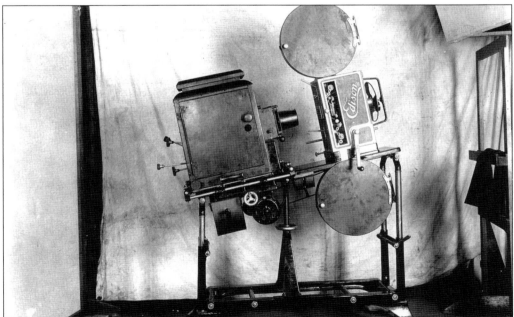

The Lumière brothers introduced a practical film projector in France in 1895. Thomas Armat and C. F. Jenkins invented a "phantoscope" projector, which they let Edison manufacture under his name, relying on the public's respect for Edison's reputation to generate profits for all. Edison later introduced his own projecting kinetoscope; this is one of his "super" models with a tilting device from 1914.

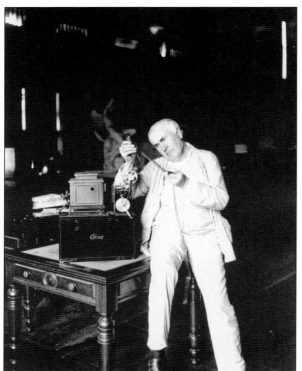

Thomas Edison examines the film for his Home Projecting Kinetoscope (HPK) in 1912, an attempt to introduce educational films into schools and the home. The film format was unusual, consisting of three adjacent strips of 5.7-millimeter film that ran through the projector in an equally unorthodox way—the middle row ran in reverse. The company made many films expressly for the HPK, although some were reformatted from the existing Edison catalog.

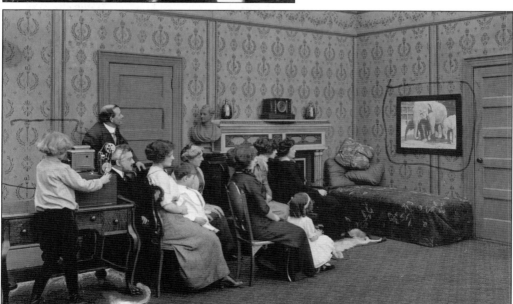

The heavy marks on this photograph show it was to be turned into an advertisement for the HPK. The elephant image has been obviously superimposed. The woman running the machine is dressed as a boy to suggest the apparatus was simple enough for a child to operate. The HPK was aimed principally at schools, but teachers showed no enthusiasm for introducing films into the schoolroom, and the project failed.

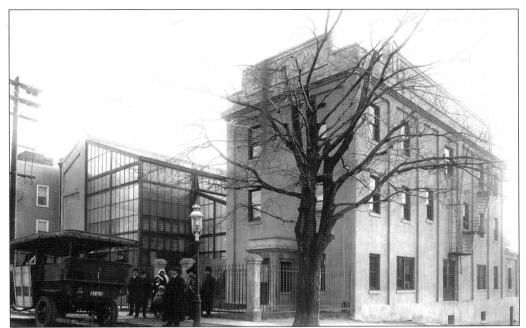

The Black Maria was succeeded by a studio on 25th Street in Manhattan in 1901. By 1907, the film business had grown so large that Edison built this studio in the Bronx, at the corner of Decatur Avenue and Oliver Place. This photograph is from 1910.

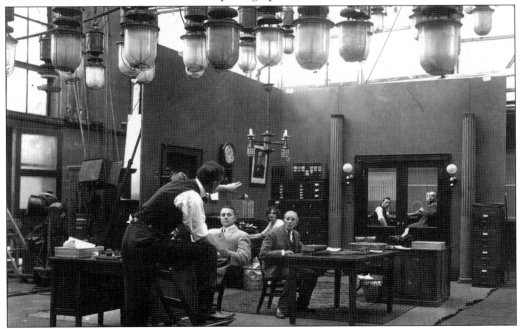

The film *Hope: A Red Cross Seal Story* is in rehearsal at the Bronx studio. The excitement of *The Great Train Robbery*, with its chases and crosscutting between two intertwined stories, had been replaced by more staid domestic and office dramas like this one, conservative both in story and filmmaking technique.

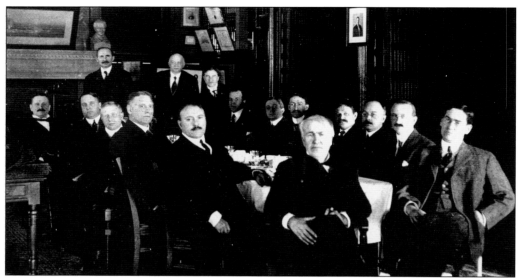

In December 1908, Thomas Edison dines in his library with the other film executives who formed the Motion Picture Patents Company. Among those present are the heads of Biograph, Pathé, Vitagraph, Essanay, Selig, and Kalem. By pooling patents they hoped to freeze out competitors. The plan failed, however, because patent infringement continued unabated, companies fled to Hollywood to escape lawsuits, and the Supreme Court ruled the Patents Company in violation of antitrust legislation in 1915.

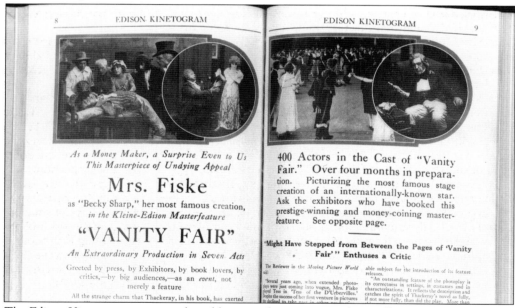

The Edison Kinetogram was a trade publication that announced new films to exhibitors. This issue features news of a 1915 production of Vanity Fair, starring Minnie Maddern Fiske, one of the most famous American stage actresses at the beginning of the 20th century. Fiske had enjoyed one of her great successes in a 1904 stage adaptation of the Thackeray novel. This is the type of "blockbuster" production with which Edison hoped to attract audiences in the waning days of his motion picture operation.

Four

STORAGE BATTERY POWER

Edison had a dual purpose in entering the storage battery business. He hoped to develop a battery that would power a practical electric automobile, and he sought an improvement on the widely used lead cell battery, which was wasteful and short-lived. He began conducting tests in 1899 and had obtained satisfactory results two years later.

In May 1901, he organized the Edison Storage Battery Company and set up a plant in an old brass mill in nearby Glen Ridge. He also built a chemical-processing facility in Silver Lake, an area that straddled the towns of Bloomfield and Belleville near Newark, where he produced the powdered nickel and iron needed for the battery's electrodes.

Introduced with much fanfare, the first batteries were badly flawed—some leaked and the electrical capacity of many cells dropped dramatically. Edison recalled all the defective cells and shut down the plant for five years, a very uncommon business practice. Edison believed that his most important asset was his reputation; after all, many people already had products in their homes that bore his name. He could not be associated with faulty goods. Extensive and costly experiments proved successful by 1909, and a new cell, the Type A, went into production.

Edison's vision of a nation of electric cars never materialized; in the years he was out of the market, automobiles powered by internal combustion engines began to fill city streets and country roads. The storage battery was nevertheless a big seller as a practical source of power for delivery trucks, lighthouses, railroad signals, railway car lighting, miners' lamps, boats, isolated farms, and as back up for generating stations. Sales of the storage battery, along with those of the business phonograph, kept Thomas A. Edison, Incorporated (TAE, Inc.) solvent in the 1920s and 1930s. The Edison Storage Battery Company, integrated into the larger corporation in 1932, continued to manufacture batteries for commercial and industrial uses into the 1960s.

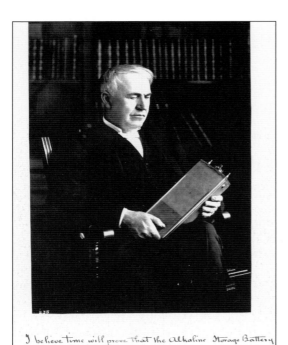

I believe time will prove that the Alkaline Storage Battery will produce important changes in our present transportation Systems

Thomas A. Edison

Thomas Edison cradles his A4 cell in the library in May 1911. His message below, written in the neat hand he had perfected as a telegraph transcriber, was incorrect. The nation turned to gasoline-powered automobiles, but his batteries did prove useful for other types of transportation.

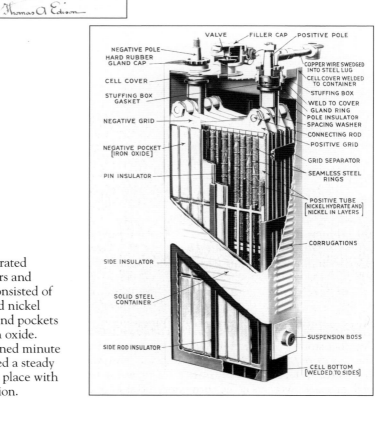

VALVE — FILLER CAP — POSITIVE POLE

NEGATIVE POLE — HARD RUBBER GLAND CAP

CELL COVER

STUFFING BOX GASKET

NEGATIVE GRID

NEGATIVE POCKET [IRON OXIDE]

PIN INSULATOR

COPPER WIRE SWEDGED INTO STEEL LUG

CELL COVER WELDED TO CONTAINER

STUFFING BOX

WELD TO COVER
GLAND RING
POLE INSULATOR
SPACING WASHER

CONNECTING ROD

POSITIVE GRID

GRID SEPARATOR

SEAMLESS STEEL RINGS

POSITIVE TUBE [NICKEL HYDRATE AND NICKEL IN LAYERS]

CORRUGATIONS

SIDE INSULATOR

SOLID STEEL CONTAINER

SIDE ROD INSULATOR

SUSPENSION BOSS

CELL BOTTOM [WELDED TO SIDES]

This cutaway image illustrated numerous advertising flyers and brochures. The battery consisted of tubes of positively charged nickel hydrate and nickel flake and pockets of negatively charged iron oxide. Tubes and pockets contained minute perforations that permitted a steady chemical reaction to take place with the help of a potash solution.

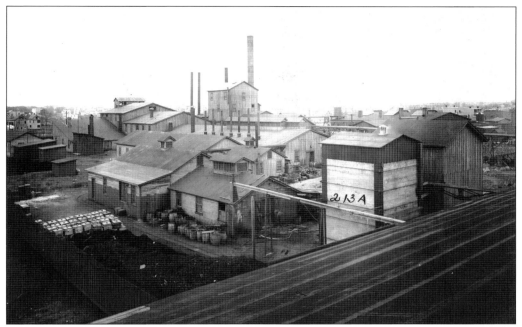

Edison built this plant in Silver Lake to manufacture his storage battery. Later he added a chemical-processing facility to produce powdered nickel and iron for the battery's electrodes. This image is from about 1914.

Another storage battery building goes up along Lakeside Avenue and Main Street, across from the laboratory. This six-story building was annexed to an existing four-story structure and completed in July 1913. The entire building was a fifth of a mile long and contained nine acres of floor space. Workers could turn out 3,000 storage cells during each 10-hour day.

This worker is perforating carbon steel ribbon—560 holes to the square inch. The ribbon was used to make both tubes for nickel hydrate and pockets for iron oxide. The perforations allow a potash solution to come into contact with both materials and facilitate the chemical reaction.

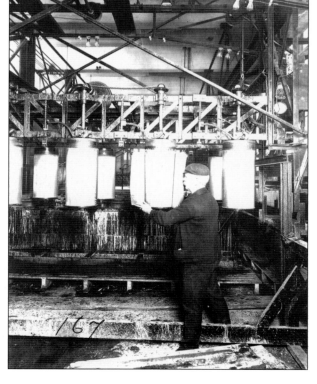

Edison found that layering nickel hydrate and pure nickel flake would yield the best performance. The nickel flake was obtained by dipping copper cylinders in a copper bath, leaving a coating of copper. Next the cylinders were dipped in a nickel bath, leaving a thin layer of nickel atop the copper. This process was repeated until each cylinder was coated with 125 layers of copper alternating with 125 layers of nickel. This man is peeling sheets from cylinders.

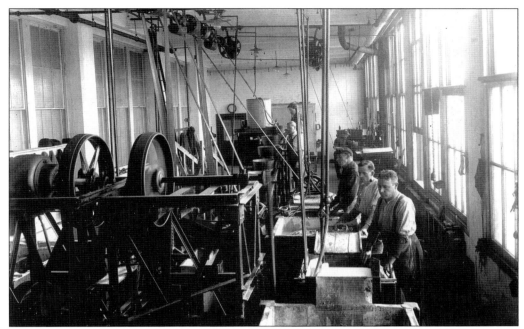

The sheets of copper-nickel are cut into pieces and immersed in a chemical bath that dissolves the copper. The centrifugal dryers at the rear of the room removed any remaining liquid from the nickel flake.

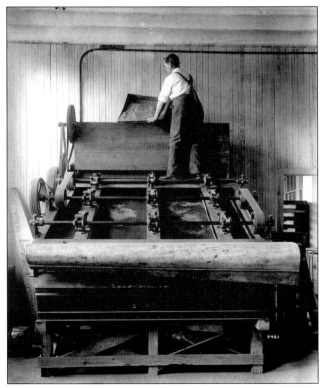

Steam coils dried the nickel flake further; workers then passed the flake through screens.

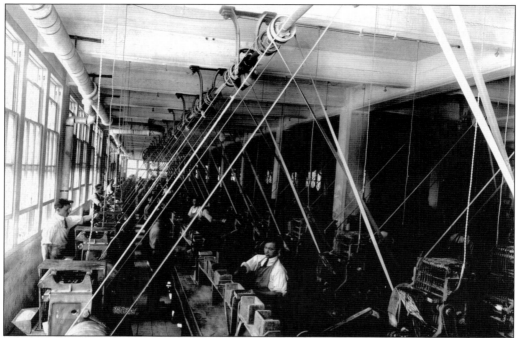

The tube-loading machines contain two hoppers, one of nickel hydrate and one of pure nickel flake. A minute amount of each is loaded alternately into the four-inch tube and tamped down by metal rods exercising pressure of 2,000 pounds per square inch. When filled, each tube contains about 630 alternating layers of the two substances.

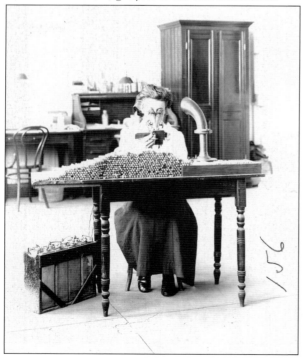

To make sure that the tube-filling machines are working accurately, one tube is selected from each lot, and a cross section is cut from it and examined under a microscope.

These workers are operating the machine that loaded the negative pockets with iron oxide.

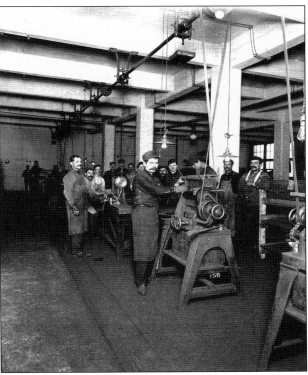

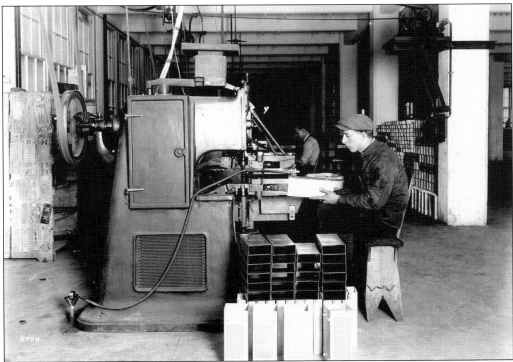

This worker is spot welding buttons on cell containers.

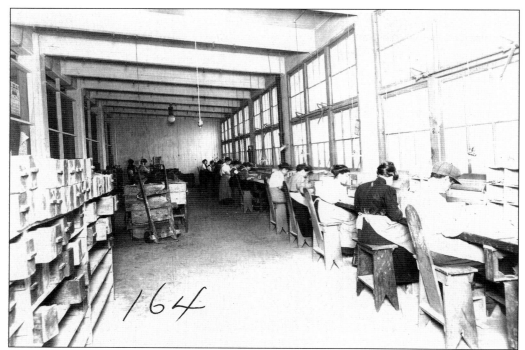

The workers in both photographs are assembling plates, about 1915. Natural light coming through the windows makes the operation easier. In the image above, a supervisor's workstation is at the center of the room. In the photograph below, workers on the left are assembling positive and negative plates, and at the right, others insert the bundled plates into steel containers equipped with rubber insulators. Finally the top is welded onto the completed cell.

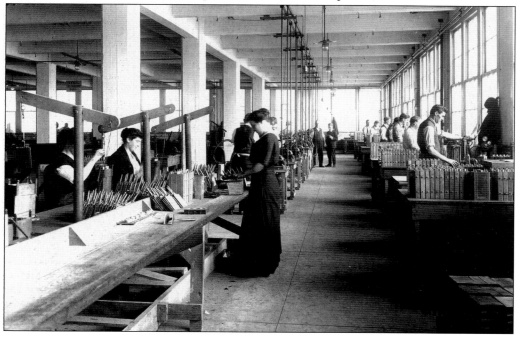

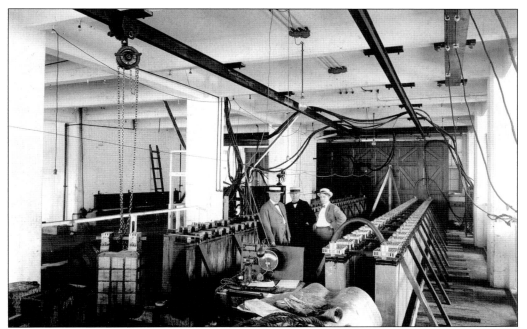

Thomas Edison is joined by Robert E. Bachman (left), of the storage battery company, and Miller Reese Hutchison, the laboratory chief engineer, in the testing room for submarine batteries. Hutchison hoped to sell batteries to the U.S. Navy, but an explosion aboard a submarine in 1916, the year after this photograph, thwarted those plans. A later investigation showed the Edison batteries were not at fault, but that they had not been properly vented by the boat's crew.

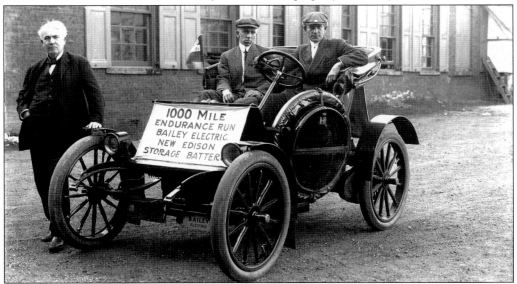

Edison had high hopes for battery-powered automobiles. This Bailey Electric, nicknamed "Maud," is driven by Capt. George W. Langdon, the test driver for the S. R. Bailey Company. His passenger is Frank McGuinness, an Edison engineer. The 1,000-mile endurance run took the 2.5-horsepower vehicle through New England and up Mount Washington in New Hampshire in 1910.

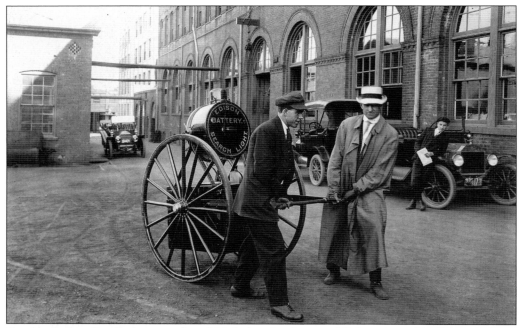

Stanley Barber (in the long coat) and his helper haul a searchlight powered by Edison storage batteries across the courtyard.

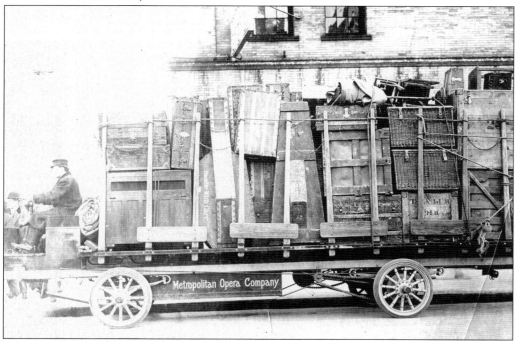

Battery-powered delivery trucks proved to be a lucrative market for Edison storage batteries. Their relatively short hauls meant a quick return to a recharging station. This delivery truck, belonging to the Metropolitan Opera Company, lumbers through the streets of midtown Manhattan, about 1913.

Storage batteries were an ideal source of power for miners' lamps. They were light, long lasting, and safe; no sparks could ignite combustibles underground.

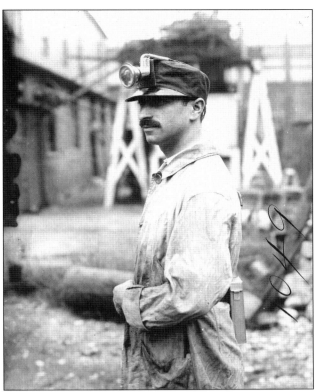

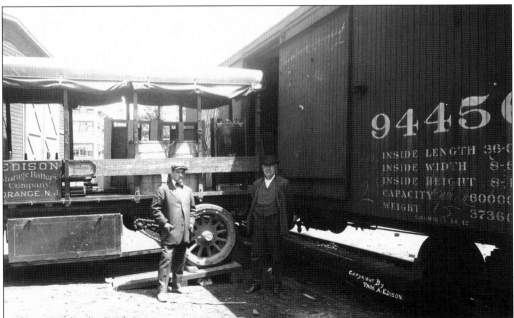

Thomas Edison and Miller Reese Hutchison stand by a railroad car that is ready to be loaded with Edison storage batteries. A spur of the Erie and Lackawanna Railroad came into the complex farther down Lakeside Avenue, expediting the shipment of all Edison products.

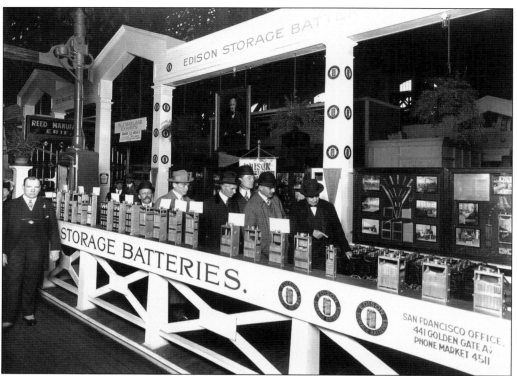

While on a visit to the Panama-Pacific Exposition in San Francisco in 1915, Thomas Edison points to his batteries at an industry trade show. Henry Ford is fourth from the right.

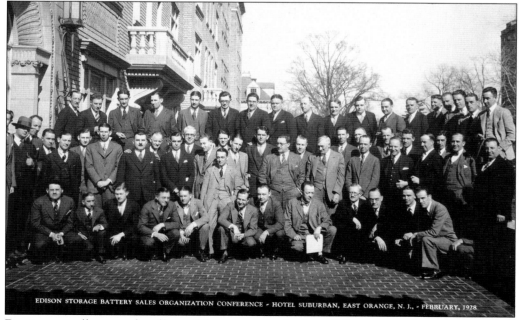

EDISON STORAGE BATTERY SALES ORGANIZATION CONFERENCE - HOTEL SUBURBAN, EAST ORANGE, N. J., - FEBRUARY, 1928

Due in no small part to the efforts of the company sales force, Edison storage batteries continued to be a reliable source of revenue into the 1960s.

Five

GIANT CRUSHING MACHINES

Edison first became interested in isolating ores while seeking a suitable metal as the filament for his incandescent lamp. Throughout the 1890s, ore milling became one of his largest projects, even an obsession.

High-grade iron ore was scarce in the eastern United States; Edison devised a series of enormous machines that would first crush large quantities of rock, then free iron from its ore using magnetic separators, and finally press powdered ore into briquettes that he would then market to iron and steel foundries. Edison installed these behemoths in a plant he built in western New Jersey near the town of Ogdensburg, about 50 miles west of West Orange. Breakdowns, fires, and collapsing structures plagued him throughout the project. In addition, the Mesabi Range, discovered in Minnesota at the beginning of the decade, provided high-grade iron ore at prices far lower than Edison's. He should have abandoned the project earlier, but he enjoyed the challenge of solving the technical problems, which, alas, he never fully conquered. He finally closed the concentrating works in 1901.

The enterprise was not an entire loss, however. Rock crushing produced sand of high quality that cement manufacturers were eager to buy. Edison adapted his crushing machinery to cement making and set up the Edison Portland Cement Company in Stewartsville, New Jersey. He developed a 150-foot kiln—far larger than any then in use—to roast the cement. Over the next decades, Edison sold huge amounts of cement to builders. He toyed with the idea of making cement products himself, even cement phonograph cabinets.

Perhaps his most altruistic idea was his plan to make cement houses a possibility for workers. A metal mold for an entire house—including spaces for electric conduit and plumbing—could be bolted together and the house "poured" in just six hours. Within a week the house would be "set" and ready for its finishing touches. Although contractors licensed the Edison process and built a few houses, the scheme was ultimately unsuccessful because start-up costs were high and the price of a finished house was just beyond the reach of the average worker. Moreover, potential middle-class buyers disliked the sameness of the houses and disdained their reputation as "working class."

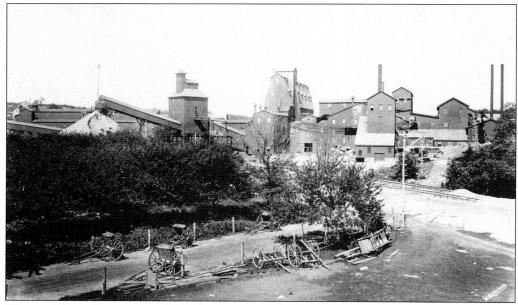

Thomas Edison first organized the New Jersey and Pennsylvania Concentrating Works in 1888. He built this plant in 1890, about five years before this photograph, near Ogdensburg in Sussex County, New Jersey. The complex included crushing rolls, ore separators, ovens for roasting ore, and briquette-making mills. Edison sold his stock in General Electric and other power companies to finance the operation, essentially severing his relationship with the electric power industry.

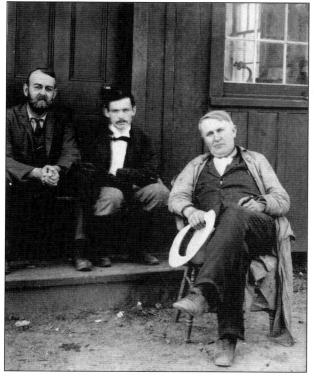

Dissatisfied with reports, Edison moved to Ogdensburg himself; here he sits by the office with Walter S. Mallory (left) and Theodore Waters, a reporter for *McClure's* magazine, who wrote about the operation. Edison returned to West Orange for weekends, saying later, "I never felt better in my life than during the five years that I worked here. Hard work, nothing to divert my thought, clean air and simple food made my life very pleasant. We learned a great deal."

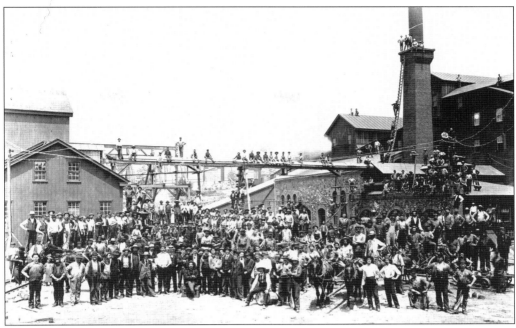

About 400 workers turned out for this photograph, taken around 1894. The work was often dangerous; injuries were frequent, and three men were killed in an 1892 building collapse. Some labor disputes occurred, and the plant was closed during most winters because the buildings were unheated. Only toward the end of the 1890s did Edison authorize the construction of housing.

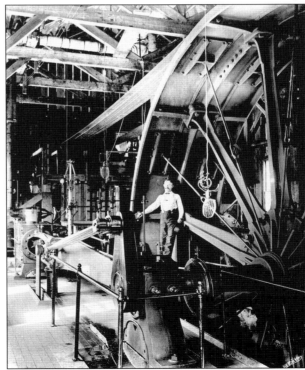

A man stands in the flywheel of the generator of the powerhouse, giving a sense of the size of the machinery that could be found throughout the plant.

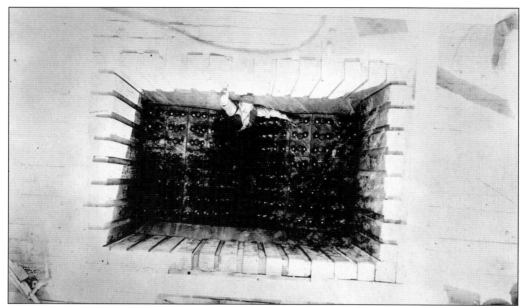

In this somewhat frightening image from about 1894, a man is standing between the giant crushing rolls looking up at the loading floor. Railway cars tipped their contents, boulders that weighed up to five tons, into this opening to be pulverized into chunks as small as two cubic feet. When first installed, the giant rolls vibrated violently and their supporting foundations collapsed. This led to yet another plant closure and extensive rebuilding.

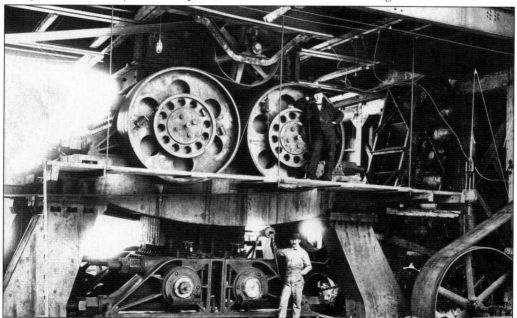

Crushed rock passed through a four-foot opening from the giant rolls to the intermediate rolls at the bottom of this image. From here the reduced rock moved on to the smaller 36-inch rolls. Initially Thomas Edison sold loose ore to companies such as Bethlehem Steel but later began concentrating the ore into briquettes.

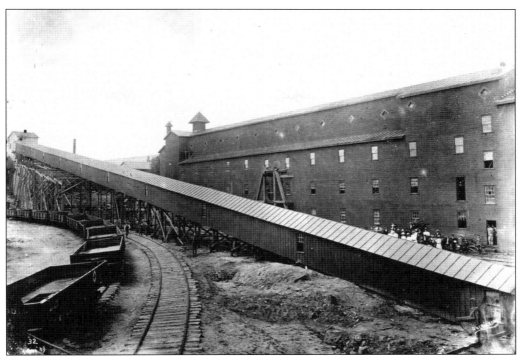

Above is the 466-foot-long conveyor that took concentrate to the Bricker Oven Building. The interior of the building can be seen below, showing the conveyor buckets themselves. The buckets would drop their loads of ore onto a bed beneath. Both photographs are from about 1894.

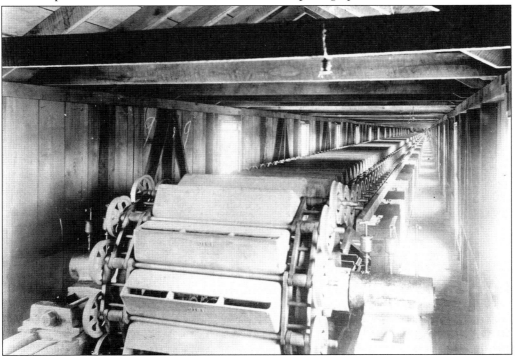

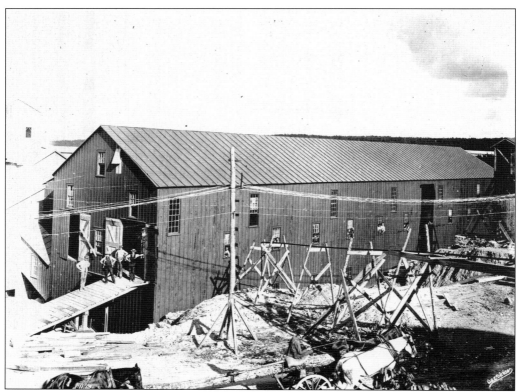

Workers in the Bricker Oven Building pressed powdered ore into briquettes. The earliest ones weighed up to 50 pounds but were later made smaller and more manageable. Fires and equipment breakdowns were constant. By 1900, Thomas Edison decided to close the plant; he later said of the money spent on the project, "well it's all gone, but we had a hell of a good time spending it."

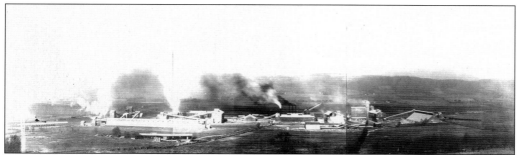

Edison formed the Edison Portland Cement Company in 1899 and built this plant at Stewartsville. This view of the plant is from about 1930. Cement manufacture, reinvented in the early 19th century after disappearing in the Middle Ages, involved many of the same tasks as ore milling: quarrying and crushing rock, analyzing samples, and packing and shipping the finished product.

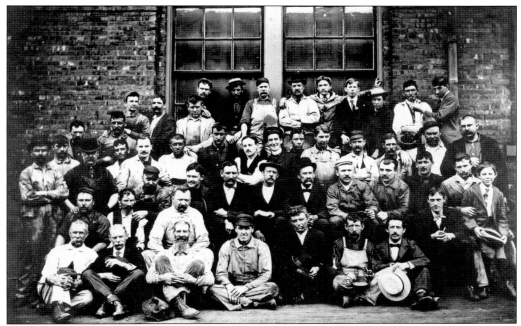

Back at West Orange, the workers who built the crushing rolls for the cement plant gather for a group photograph in front of Building 5 in 1900. During both the ore milling project and the early days of the cement plant, much testing and machine fabricating were done at West Orange and the finished parts were shipped out to western New Jersey.

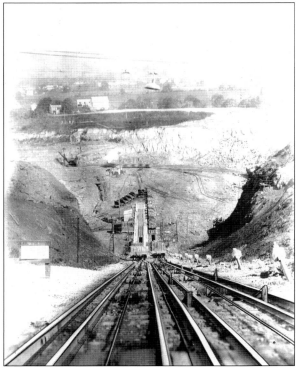

The electric cable railway tracks drop vertiginously into the cement quarry. The plant was near the Delaware, Lackawanna, and Western Railroad that provided connections to major markets. Limestone, which was mixed with cement rock, could be quarried a few miles away. Why *Portland* cement? When cement making was rediscovered in Britain in the 1820s, its makers thought it resembled the building stone quarried on the Isle of Portland, off the English coast.

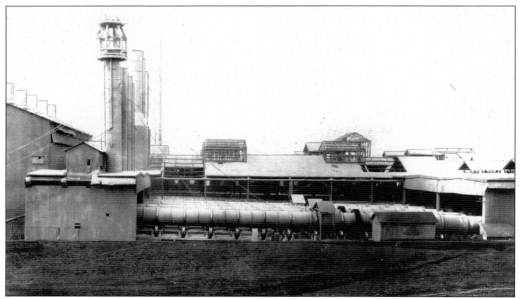

These are the 150-foot rotating cylindrical kilns that Thomas Edison developed to roast limestone and cement rock, melding the two into "clinkers" of cement. Edison also developed a series of automated analysis stations that permitted the proportions of ingredients to be adjusted when required. The huge capacity of the Edison kilns produced a glut of cement and falling prices by 1910. This photograph is from about 1930.

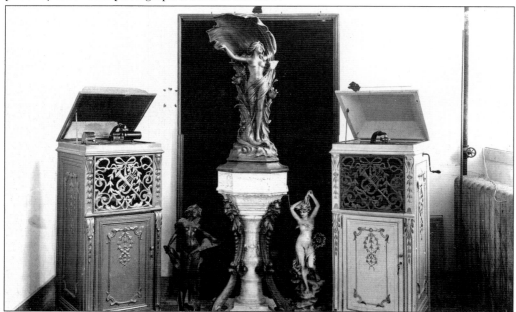

Would the public buy cement furniture? Edison had his engineers make some model phonograph cabinets in 1912. (The one in the center has its phonograph in the pedestal just below the statue.) He also considered cement refrigerators and pianos. Cement furniture was never a success, however. Problems included poor mold design and rough surface finishes, surface flaking, brittleness, and, of course, prohibitive weight.

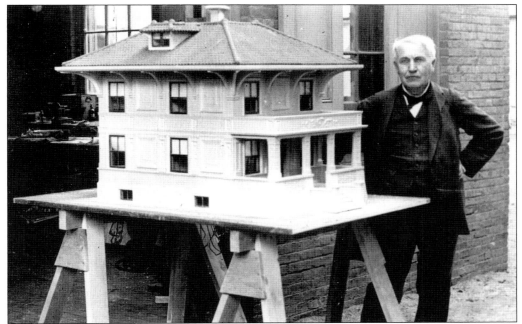

Edison poses with this wood model of a cement house in 1910. He wrote, "I think the age of concrete has started and I believe that I can prove that the most beautiful houses that our architects can conceive can be cast in one operation in iron forms for a cost which will be surprisingly low."

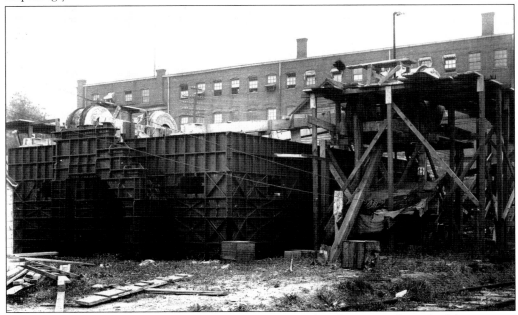

Workers assembled a complete mold for a house across Lakeside Avenue from the laboratory in 1911. This land would be occupied by the Edison Storage Battery building a year later. The mold was made up of dozens of heavy metal plates that were bolted together like a three-dimensional jigsaw puzzle. Also in place is the machinery for pouring the cement.

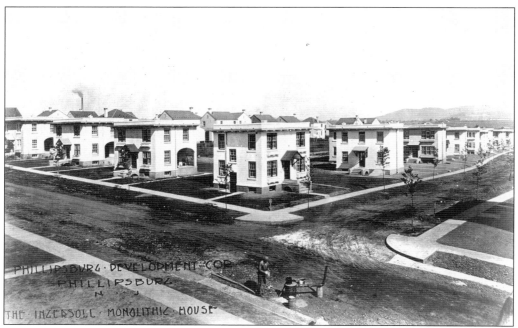

Charles A. Ingersoll built several cement houses in Phillipsburg, New Jersey, but his effort was not widely replicated. Some problems, beyond buyer reluctance, included substantial start-up investment, the high cost of materials, and resistance from conservative building trades. This view of Ingersoll's Monolithic Houses is from 1935.

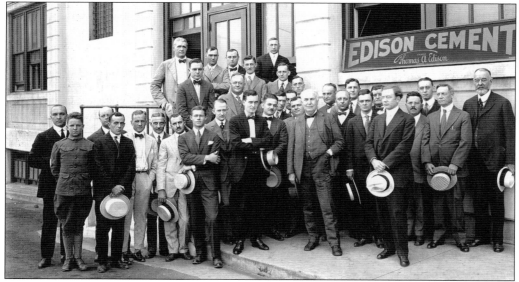

Thomas Edison and the sales staff of the Edison Portland Cement Company stand outside the company offices in August 1916. Charles Edison stands to the left of his father. After Thomas's death, the company became the Edison Cement Corporation. The cement business could only generate profits, however, if demand and prices were both high. By the mid-1930s, the plant closed and was sold in 1942 to the Chilean Import Company, which dismantled the equipment and shipped it south.

Six

A Host of Other Products

Edison's enterprises encompassed other, less well-known, product lines: primary batteries, chemical production, small kitchen appliances, and even children's furniture. His final experimental campaign was a search for a domestic source of natural rubber.

Edison began manufacturing primary batteries under a license from the French inventor Félix Lalande in 1889. While a storage battery converts chemical energy into electrical energy by reactions that are reversible simply by recharging the battery, the chemical reaction of a primary battery is irreversible; the battery must be renewed by replacing all of its contents. The manufacture of primary batteries, ideal for remote locations, proceeded in tandem with Edison's storage battery business.

Edison used huge amounts of carbolic acid to make his storage batteries and phonograph records. The outbreak of the First World War prevented its import from Britain and Germany. But even by 1913, Edison had begun building a chemical factory on the site of his storage battery plant in Silver Lake and was soon making six tons of carbolic acid a day; manufacturers were avid to buy his surplus. He later built additional plants to collect benzol and other chemicals at steel companies in Pennsylvania and Alabama (the coke ovens of steel foundries produced benzol as a by-product). These leased plants operated for three years, during which time other companies entered the market, and Edison's sales shrank. He phased out his rented operations by 1920 but continued to maintain the chemical works in Silver Lake.

In the late 1920s, Edison introduced a line of luxury kitchen appliances called Edicraft—coffeemakers, sandwich grilles, toasters, waffle makers, and irons. But their high prices and the beginning of the Depression quickly doomed the enterprise.

With the backing of his friends Henry Ford and Harvey Firestone, Edison began his last major project in 1927, the search for a domestic source of natural rubber. Over the next four years, his staff tested over 17,000 latex-bearing plants, settling finally on goldenrod. By careful crossbreeding, the Edison team produced a much taller plant and raised its rubber content from 4 percent to 12 percent. Following Edison's death in 1931, Ford continued to support the project, but by the early 1940s, scientists had produced synthetic rubber from petroleum by-products.

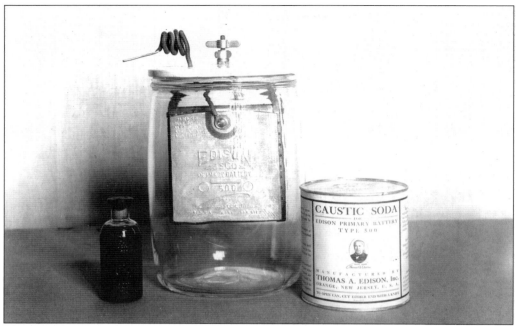

Thomas Edison's primary battery consisted of a heat-resistant glass (or enameled steel) jar with a porcelain cover, a set of terminal nuts and washers, and an element (an assembly of copper-oxide and zinc plates suspended within the jar). The contents of a can of caustic soda and a bottle of oil permitted the chemical reaction to take place. The cells came in several sizes, designated by letter.

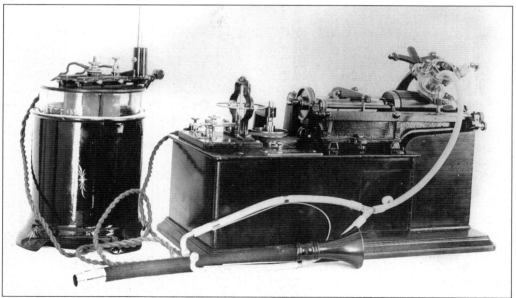

An 1889 model of an Edison phonograph is attached to a primary battery. The discoloration of the liquid in the jar suggests that the reactants have been exhausted and the contents need to be replaced. Over the decades, Edison exploited new markets for primary batteries, such as highway signals, aircraft and marine signaling, electric lamps, and navigation devices.

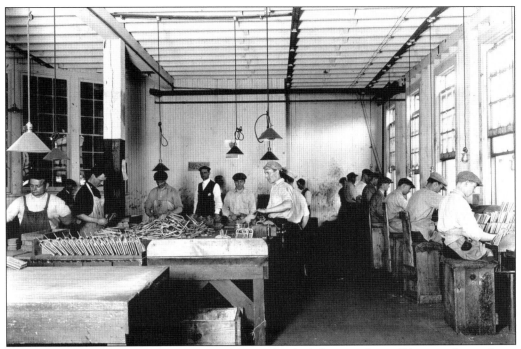

In the photograph above, workers are assembling individual elements that will be joined into plates. Seen below, cans of caustic soda are being filled and inspected in the soda department at the Silver Lake factory. Edison continued to patent improvements on the basic copper-oxide cell, production methods, regenerative compounds, and product design. The company later adopted a recycling program for copper-oxide elements.

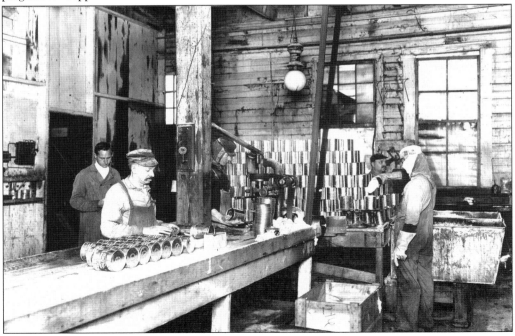

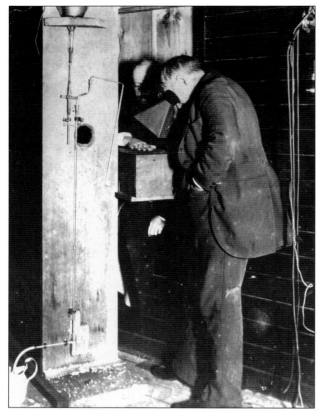

A fluoroscope is a box through which one can view x-ray images. Only a few months after Wilhelm Roentgen discovered x-rays in 1895, Thomas Edison was pursuing a commercially successful fluoroscope. In the photograph above, he views an assistant's hand through the fluoroscope. In the image below, Charles Dally looks through a fluoroscope poised above the apparatus used to generate x-rays. By the summer of 1896, Edison was manufacturing the devices at West Orange. He declined to take out a patent on the device, preferring to make it available to the medical and scientific communities for use and improvement. The project was not without human cost, however. Clarence Dally, brother of Charles, developed cancer, suffered amputation of both arms, and died from his prolonged x-ray exposure.

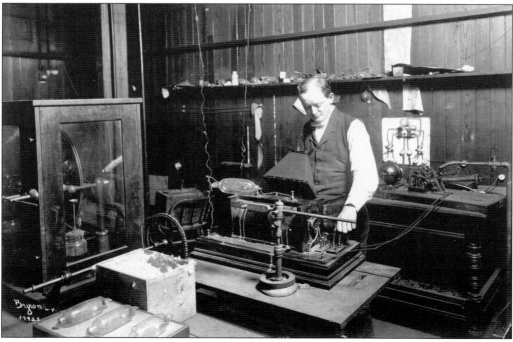

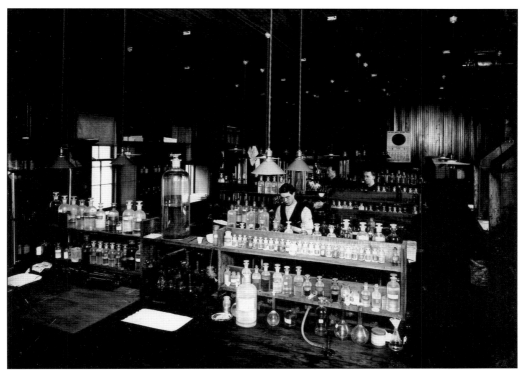

The staff is at work in the laboratory of the Edison Chemical Works at the storage battery plant in Silver Lake. Edison built a chemical factory on the grounds of this plant in just 18 days. When planning this or any of his chemical plants, Edison analyzed the problem, settled on the best production methods, and then set teams to build the plants and make them run efficiently. In the image below, workers are beginning construction of yet another new building at the site. The horse-drawn wagon in the center background indicates that no matter how modern the factory or its products, the construction crew must still sometimes rely on the oldest methods of transportation.

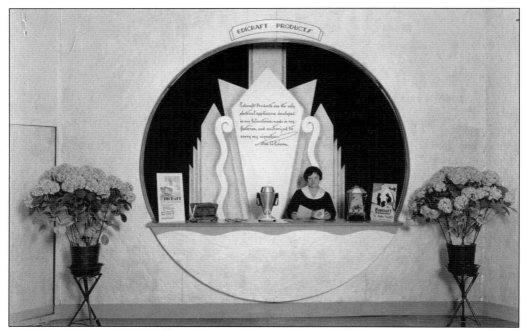

When Thomas Edison stopped manufacturing entertainment phonographs in 1929, the assembly lines were idled. To bring them back on line, he introduced a range of luxury kitchen products called Edicraft that included toasters and coffeemakers like these on display at an unidentified trade show.

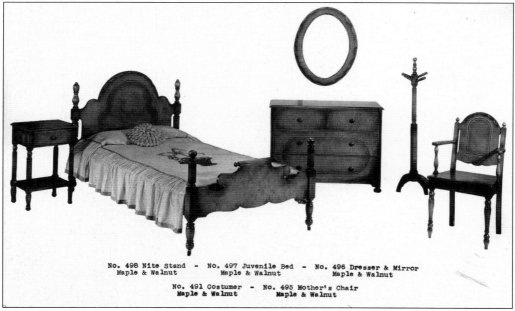

No. 498 Nite Stand - No. 497 Juvenile Bed - No. 496 Dresser & Mirror
Maple & Walnut Maple & Walnut Maple & Walnut

No. 491 Costumer - No. 495 Mother's Chair
Maple & Walnut Maple & Walnut

Edison bought the Wisconsin Cabinet and Panel Company in New London, Wisconsin, to make phonograph cabinets and the fine veneers that covered the more expensive models. The company employed about 500 workers and also produced theater seats and children's furniture, some examples of which are shown here.

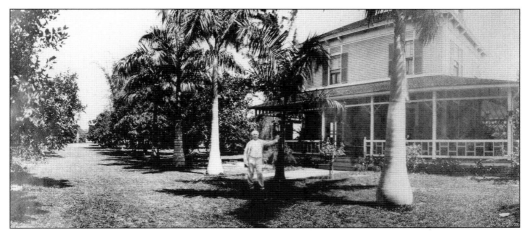

In the photograph above, Edison stands in front of his home, Seminole Lodge, in Fort Myers, Florida, in 1912. He and his second wife, Mina, spent most winters here, and the estate, equipped with its own laboratory, became the focal point of Edison's search for a domestic source of rubber in case another war cut off imports. In the photograph at right from 1931, Edison and an assistant flank a sample of goldenrod (*solidago leavenworthii*) that his staff had bred. In July 1936, Mina and her son Charles dissolved the Edison Botanic Research Corporation, but Henry Ford continued goldenrod work on his Savannah, Georgia, plantation. Later the U.S. Department of Agriculture took over the project, supervising Ford's plantation and continuing to experiment with crossbreeding and the vulcanization of goldenrod rubber through the early 1940s.

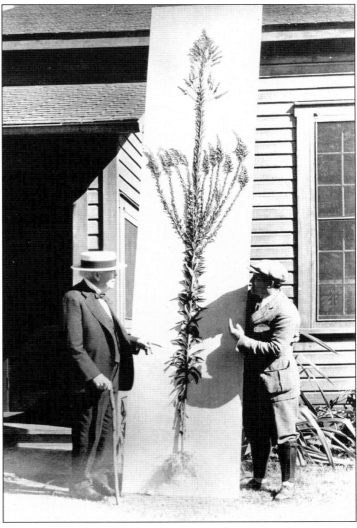

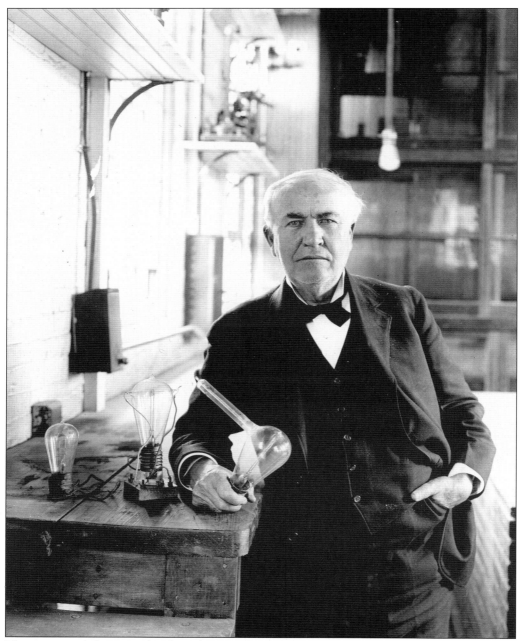

This is one of the most familiar photographs of Thomas Edison, but he is not holding an incandescent lamp. The device is an Edison Effect bulb. In 1880, Edison noticed a mysterious build-up of carbon on the inside of incandescent bulbs, and he devised this bulb with a third electrode to measure the electrical charge that was moving through the vacuum inside. He named the phenomenon the "Edison Effect," but he could never find a satisfactory explanation for it. Other scientists later discovered that the Edison Effect could be used to track radio waves, and Lee DeForest built on Edison's discovery to develop the vacuum tube, essential to both radio and television.

Seven

WORKING FOR
MR. EDISON

Many of the first muckers had been with Edison since Menlo Park and had endured the rigors of installing electrical generating plants in New York, other cities around the country, and across Europe. They were skilled craftsmen with varied backgrounds, some with formal high school and college training in mathematics and science, most with practical experience picked up in workshops and factories, on the railroads, and in mines and oil fields. They hailed from around the country and abroad, all eager to be part of this new laboratory. They were assisted by boys who did the sweeping, the hauling, and even some note taking, eager to move up to more important assignments.

The factories surrounding the laboratory were filled with skilled and semi-skilled workers who assembled Edison products. Nearby towns, such as the Oranges, Montclair, Bloomfield, and Glen Ridge, and larger cities like Paterson, Newark, and New York City, supplied the workers. Company officials would travel to nearby Hoboken and Jersey City to recruit immigrants who had just survived the rigors of Ellis Island.

Eventually a white-collar workforce joined the mix as business expanded to meet the demands of a growing corporation. In the mid-1920s, Edison even began administering a written test of his own devising to job applicants—a test that called on the candidates' memory, reading, and practical knowledge.

Edison was hostile to trade unions and responded to business downturns with widespread dismissals of office and factory workers. Despite this, the Edison complex took on the character of a town within a town; the new factory buildings offered cafeterias, an infirmary, even a branch of a local bank. New employees underwent training to operate the complicated and dangerous machinery. A newspaper, the *Edison Herald*, circulated throughout the labs and the factories. Sports teams flourished, and a web of social events such as dances, sing-alongs, and the annual Edison Field Day of picnicking and athletic competition helped the diverse, polyglot workforce to forge a sense of community.

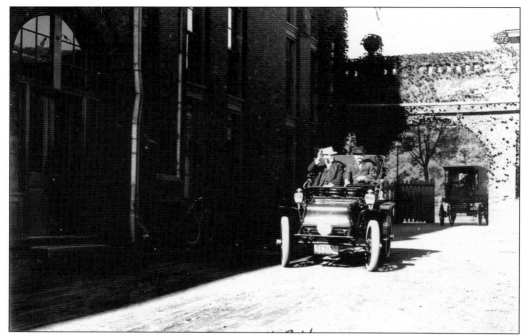

Thomas Edison returns to the laboratory on October 9, 1911, from a family trip to Europe. Fred Ott, star of that early film *Edison Kinetographic Record of a Sneeze*, is at the tiller. The Edisons visited Britain, France, Switzerland, Austria, and Hungary. He shunned publicity along the way but was frequently recognized and mobbed by well-wishers. In Paris, Edison was reunited with his daughter Marion whom he had not seen in 17 years; she lived in Germany with her husband. In the picture below, laboratory employees line up to shake the old man's hand and then file into Building 5.

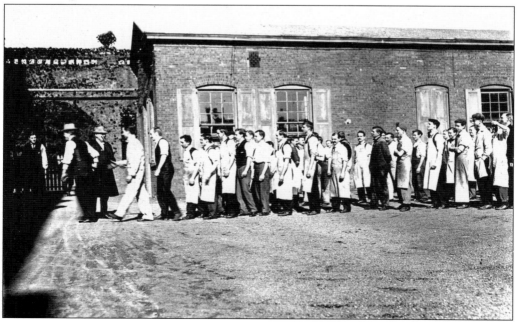

Laboratory workers organized a formal club, "Muckers of the Edison Laboratory," in 1902 for "the avowed purpose of holding certain meetings of diverous [sic] sorts. . . and. . . conducting ourselves in a manner productive of jollity and of good friendliness." Membership was based on nomination and election by the members. They held outings and meetings at area restaurants. The organization appears to have ceased functioning by 1909.

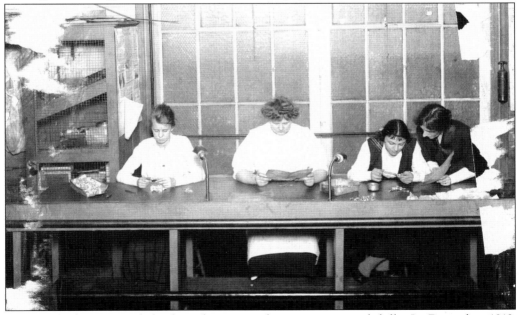

A training department helped teach new employees a variety of skills. In December 1919, these women are learning to be factory inspectors; the woman at the right is examining their written work.

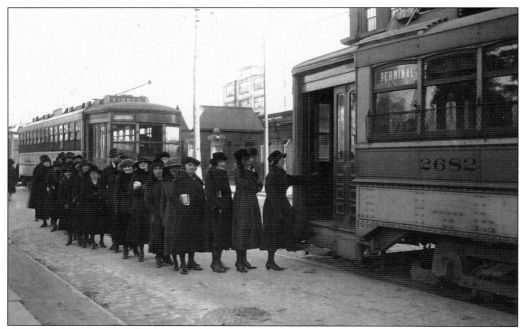

Training went beyond the workbench. These employees are learning to board the trolleys on Main Street in a safe, orderly manner. This is a Saturday at noontime, the end of the workweek. The picture accompanied a front-page story in a February 1919 issue of the *Edison Herald*.

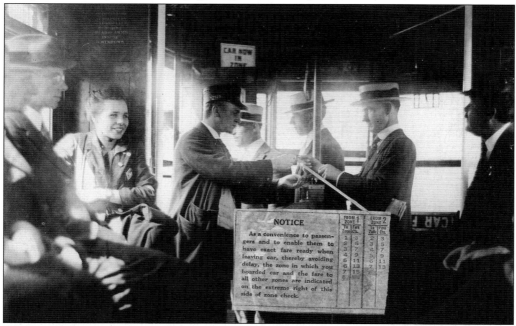

Passengers board a trolley and learn to use new zone checks. An actual zone check is attached to the photograph, and a line drawn in white ink points to a zone check in the conductor's hand. This photograph illustrates an article in a September 1919 issue of the *Edison Herald* that informed employees how to use the new system devised by the trolley company.

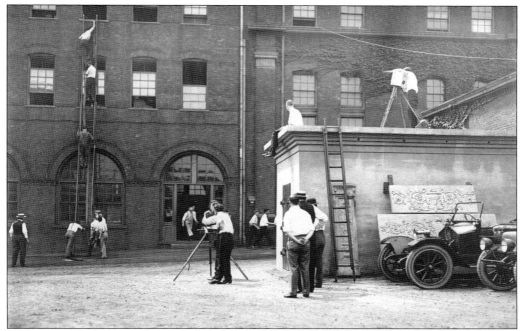

In the photograph above, the cameramen on the ground and atop Vault 8 are filming a fire drill in 1912. Perhaps company officials will use the film to evaluate the efficiency of the operation later. Laboratory workers descend the ladder from the third floor of Building 5 while other workers exit the front door and turn right toward the main gate (their route can be seen in the lower photograph). The decorated cement panels leaning against the vault were made for Edison cement houses. A narrow emergency ladder was added to the Building 5 sometime after this picture was taken.

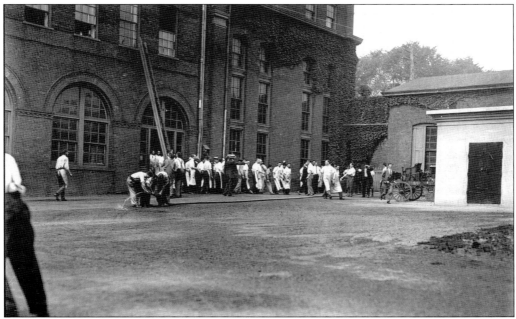

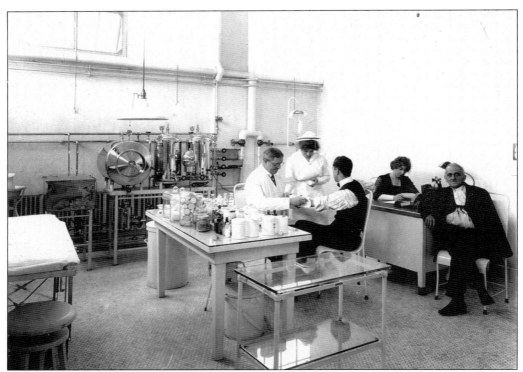

Dr. Charles W. Banks and nurse Irene Yerkes assist employees in the dispensary in 1919.

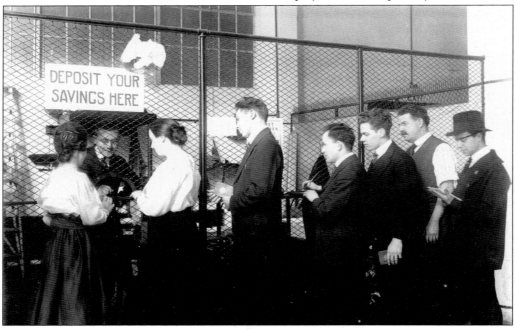

Employees line up to make deposits at the Edison branch of the Second National Bank of Orange in April 1917. The branch was located on the first floor of Building 15, which was centrally located at the Edison complex. The branch was open Thursdays, 2:00 p.m. to 5:00 p.m.

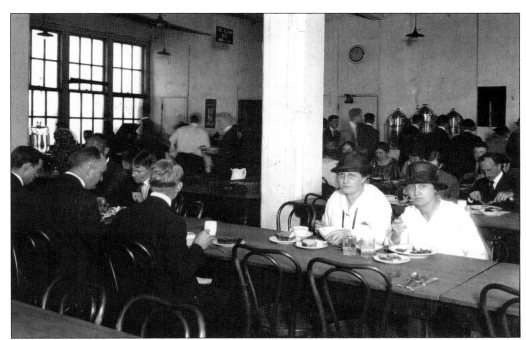

A flyer provides a full description of the employee cafeteria, photographed in August 1919. "The Edison Restaurant in the Edison Storage Battery Building has ample accommodation for Edison Workers, who may take their own lunches to tables there at noon. No Charge for This Accommodation . . . Regular Luncheons Served in Private Rooms for 50 Cents . . . Special Rooms for Ladies." Additional lunch choices included soup for 5¢, a ham sandwich for 10¢, and ice-cream sundaes for 10¢. In the image below, the restaurant staff members enjoy a meal of their own; May Walmsley, the restaurant manager, is at the head of the table in this March 1920 photograph.

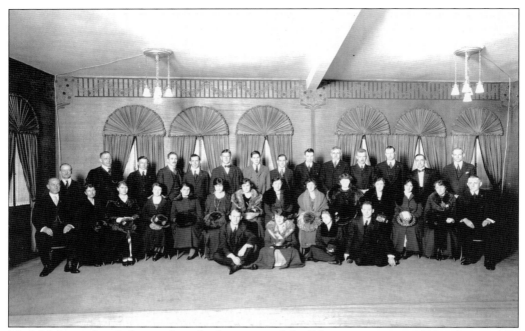

Mark M. Jones, fourth from right in back row, joined the Edison company in 1916 and eventually became head of the personnel department. His staff joins him here in the department office in February 1920. He was responsible for establishing the cafeterias, dispensary, bank branch, and other amenities, partly in the hope that they would foster employee loyalty and discourage flirtation with trade unions.

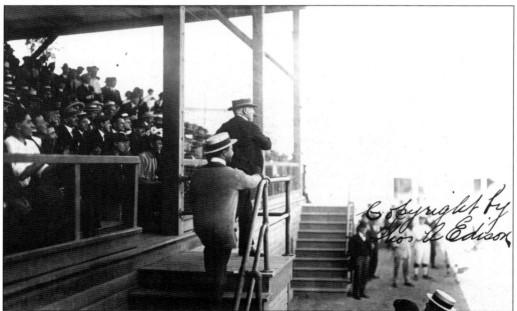

Thomas Edison has just thrown out the first pitch at a baseball game, part of the annual Edison Field Day competition on May 26, 1914. He stands on the bleacher steps at Olympic Park in Irvington, New Jersey, near Newark.

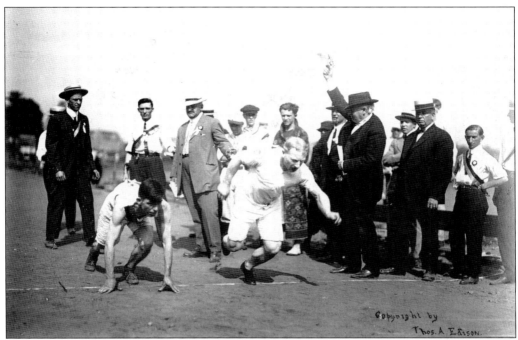

These are from the Edison Field Day competition held in 1913. In the photograph above, Edison fires the starter's pistol to begin a race; below a broad jump contestant recovers after her attempt. Each year the *Edison Herald* was filled with articles anticipating the upcoming games. Extensive competition results were published in the issue following the event.

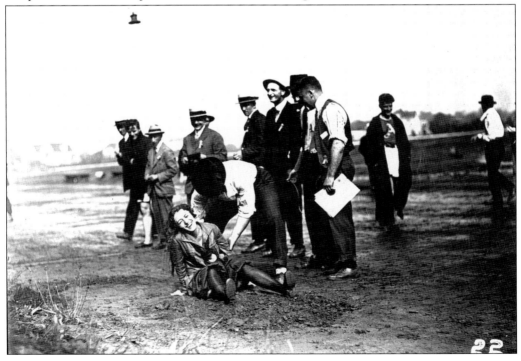

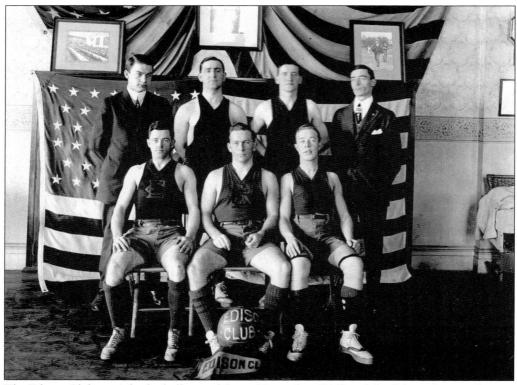

The Edison Club men's basketball team (above, November 1913) and the Edison Storage Battery bowling team (below, May 1917) were two of the many sports organizations that were active from 1910 through the 1920s.

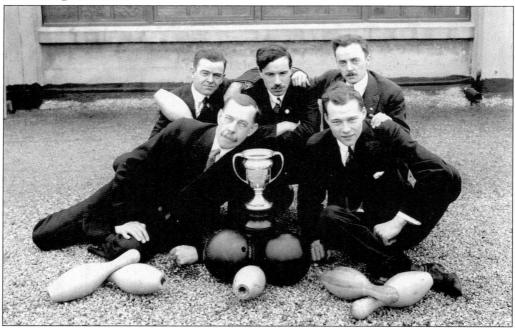

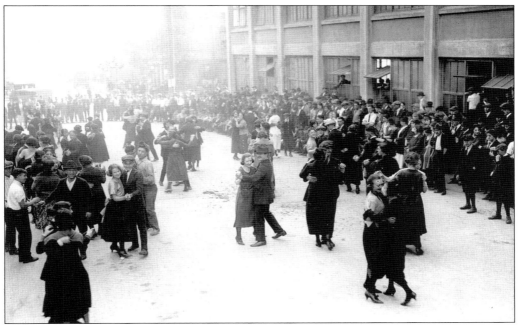

Dancing breaks out on Lakeside Avenue (above), and below some employees dance to phonograph music at noontime. It is unclear just where these women worked, but their aprons suggest they might be waitresses in the employee restaurant. Both photographs are undated but are probably from the period of 1915–1917.

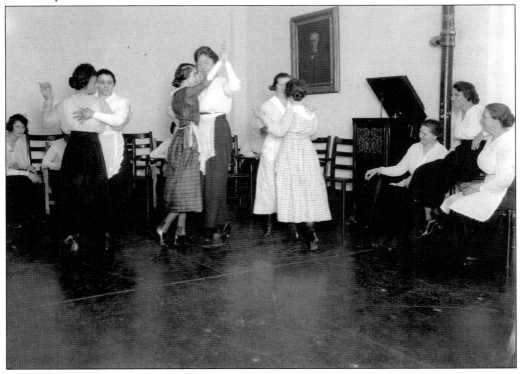

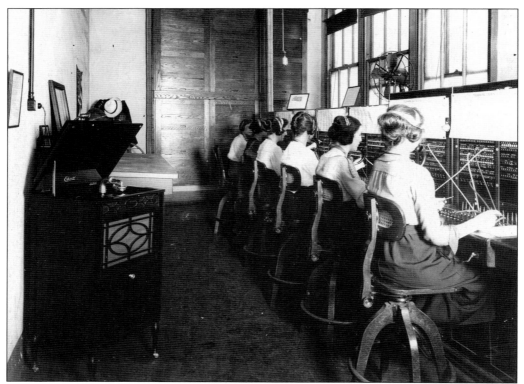

The telephone switchboard in the administration building handled about 5,000 calls a day in 1919, the date of this photograph. During night shifts, operators would send musical greetings to their colleagues at the telephone company switchboard in Orange and to long-distance operators by placing a telephone directly in the phonograph horn (hidden by the mesh grille on the front of the machine).

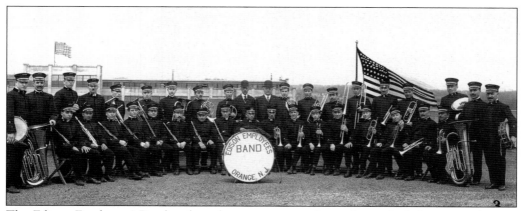

The Edison Employees' Band gathers for a group portrait on the roof of the storage battery building in May 1917.

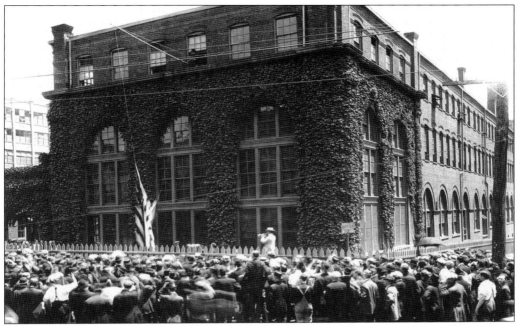

The *Edison Phonograph Monthly* stated that the deteriorating political situation in Europe gave Flag Day 1914 a special urgency. Company officials invited all employees to turn out at 12:05 p.m. on June 14. A bugler opened the ceremony, and chief engineer Miller Reese Hutchison made brief remarks to the gathering. Singers closed the program with the "Star Spangled Banner." It was the first such Flag Day observance at the laboratory, and it became a tradition.

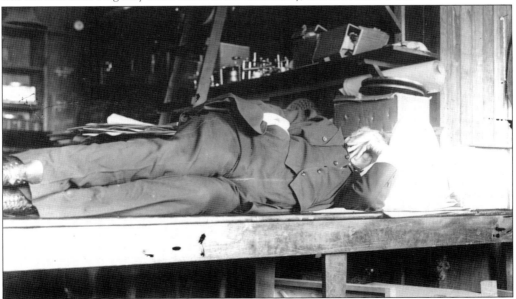

Edison was well known for taking short naps wherever he happened to be, here on a workbench, for example, in 1911. It enabled him to remain alert for days at the laboratory that often stretched into the night. Mina Edison, apparently more concerned for her husband's dignity than he was, sent down a cot for him to use in the library.

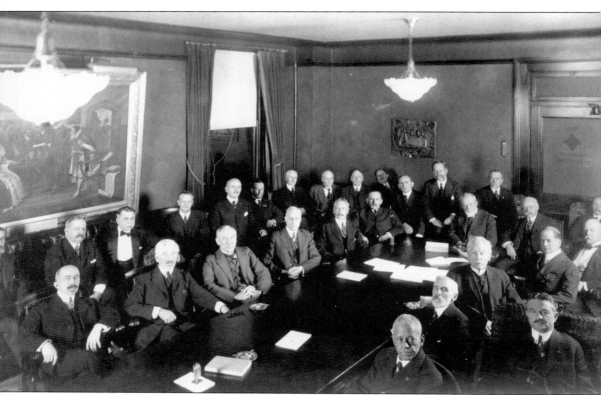

The founding members of the Edison Pioneers held their first meeting in January 1918. The idea of an organization of early Edison employees was born the previous year at a luncheon celebrating Thomas Edison's 70th birthday. The purpose of the organization was to honor Edison and his inventions, particularly the early ones, and to maintain social and intellectual connections among former colleagues. A few people, including Edison and members of his family, received honorary memberships. The Edison Pioneers met annually on or around Edison's birthday; they worked on a number of projects, including erecting commemorative tablets and a memorial tower at Menlo Park and assembling a collection of artifacts to donate to the Henry Ford Museum in Dearborn, Michigan. In 1957, the Edison Pioneers merged with the Thomas A. Edison Foundation.

Eight

THE LATER DECADES

The business successes of the early 1900s turned to a slump by 1910, helped along by the lingering effects of the Panic of 1907. Increased competition depressed phonograph sales. The storage battery business was closed for much of the decade while Edison solved its many technical problems. Overproduction in the cement business depressed prices and profits. Reorganization was necessary; the flagship of the Edison companies, the National Phonograph Company, founded in 1896, became TAE, Inc., in 1911 and embraced most of the Edison companies. The purpose of the new corporation was to provide financial support for its constituent parts.

Only three years later, a disastrous fire broke out on December 9, 1914. Starting in some wooden buildings that stored flammable motion picture film stock, the fire quickly consumed the film and the buildings, and spread to the supposedly fireproof concrete buildings of the Phonograph Works, which stored the highly flammable chemicals and resins used to make phonograph cylinders and discs. Edison vowed to rebuild and resume production. He was back in business, remarkably, in just a few months.

During the 1920s, the laboratory was no longer in the forefront of invention. The research and development laboratories that had grown up in other corporations over the decades were of a different character, more narrowly focused on the specific business interests of their parent companies. Their staffs were not permitted—or inclined—to range freely over all technical fields, as Edison and his muckers had done in 1887. The Edison factories continued making the most profitable products, business phonographs and storage and primary batteries. Edison himself, entering his 80s toward the end of the decade, was coming to the end. These later years were filled with honors and awards offered by a public grateful for his earlier contributions.

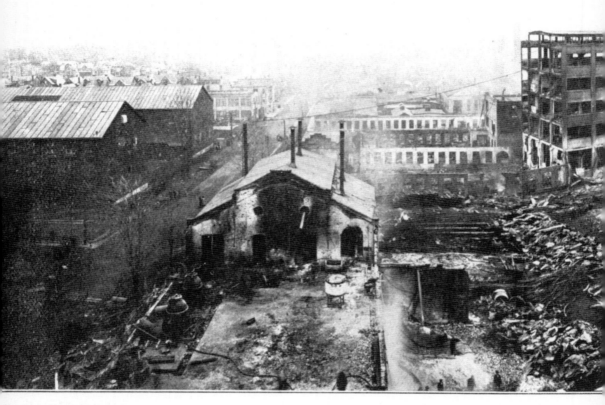

ectrical and Kinetophone
pts.—Untouched

Punch Press Dept., Brick and Steel
Machinery Salvaged
Shipping Dept., Brick and Steel
Total Loss

Part of Disc Plant, Brick and Steel
Almost Total Loss

Drill Press a
Concrete—Fa

General View o.

This view does not take in the Record

The great fire began about 5:30 p.m. on December 9, 1914, and before it was put out the next day had consumed four city blocks. Flames leaped into the night sky and could be seen seven miles away in Newark. Water pressure was insufficient to fight the flames, and fire companies from several surrounding towns rushed to help. The next morning, it was clear that 13 buildings had

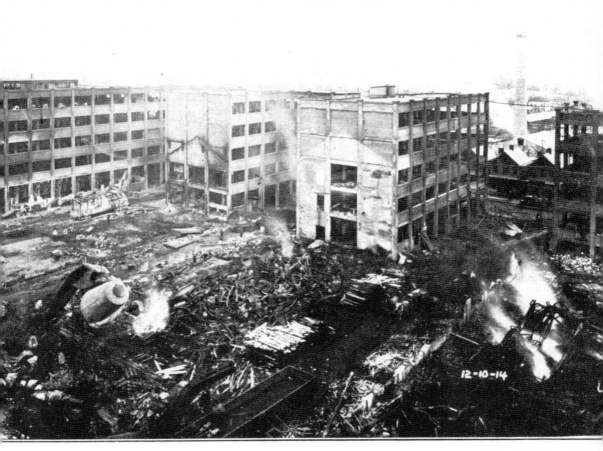

12-10-14

ew Machine Dept.,
age
 Film Inspection Dept.,
 Iron—Total Loss

Screw Machine Dept., Concrete
 Fair Salvage
Corrugated

Cabinet Shop, Wooden
 Total Loss

Cabinet Finishing Dept., Concrete
 Fair Salvage

Office Building, Concre
 Fair Salvage

Record Stock and Manufacturing De
 Brick and Steel—Total Loss

e Burned Area

nt or much of the Office Building

been badly damaged or completely destroyed. Thomas Edison had come down early to observe the fire and by 10:00 p.m. had begun making notes on what needed to be done to recover. Within three months, some manufacturing resumed in the undamaged Edison Storage Battery building across Lakeside Avenue from the laboratory.

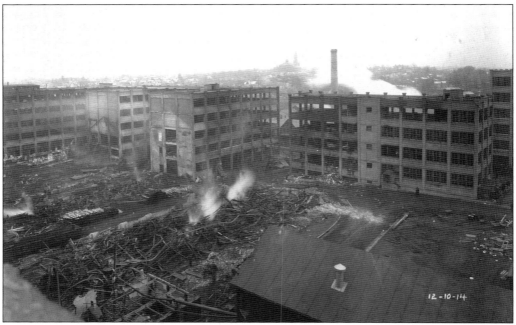

This view to the northeast shows that firemen had checked the blaze by the time it reached the western end of the administration building at the right. The original brick laboratory buildings, just beyond the frame to the right, escaped damage. The unharmed storage battery building, across Lakeside Avenue, is just visible at the extreme right.

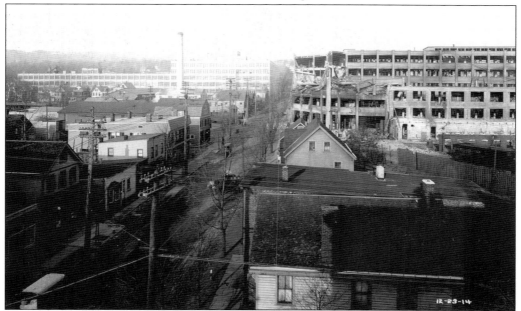

The view looking west up Lakeside Avenue shows the ruins of the film plant on the right and the pristine storage battery building on the left. This image also reveals how close residential areas lay to the factories. No houses burned, however, thanks to the efforts of the many fire teams that responded.

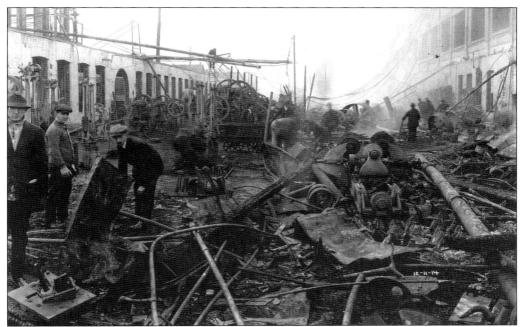

Workers pick through the debris of the punch press room and the horn tin shop two days after the fire. Regular fire drills were apparently effective; only one man lost his life in the fire, and he had gone back into a burning building.

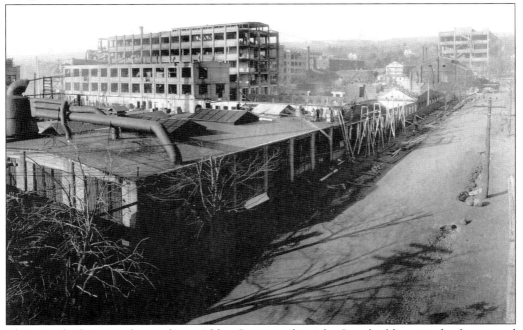

This view looking northwest shows Alden Street to the right. Low buildings in the foreground that housed the buffing and horn-making departments were saved. The film department and the cabinet shop in the middle distance were lost. At the end of Alden Street is Building 24, which was badly damaged.

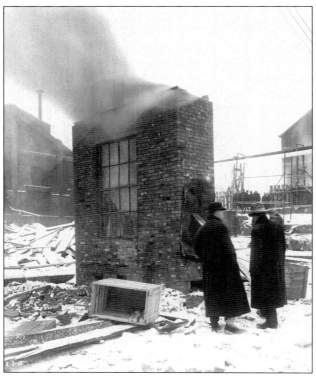

This chimney was constructed in February 1915 amid the rubble of the fire in order to test two different kinds of wire-glass windows equipped with steel frames and sashes. Both were designed to retard fire; the safety windows would be incorporated into the repaired buildings.

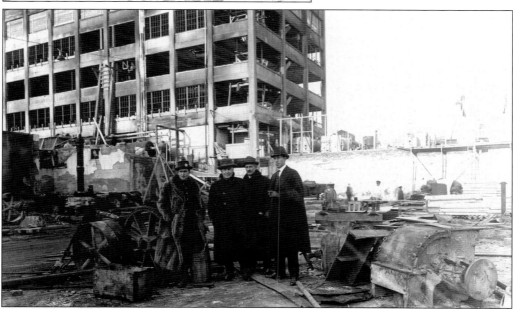

From left to right, Charles Edison, his father, C. H. Wilson (vice president and general manager of TAE, Inc.), and an unidentified man stand in the yard on December 22, after much rubble had been cleared away. The night of the fire, Thomas called to Charles, "Wake up mother," so she could see the spectacle. Actually, Mina Edison had the presence of mind to have many documents and models removed from the laboratory to the safety of the storage battery building.

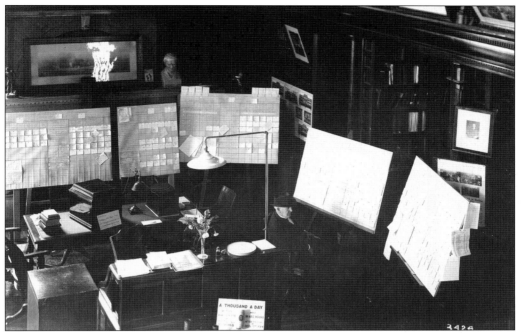

Just one month after the fire, Edison sits in the library looking at the progress boards that track the pace of reconstruction. The fire was not without its benefits; several product lines were consolidated and retooled to permit the use of interchangeable parts. Other unprofitable products were allowed to expire quietly.

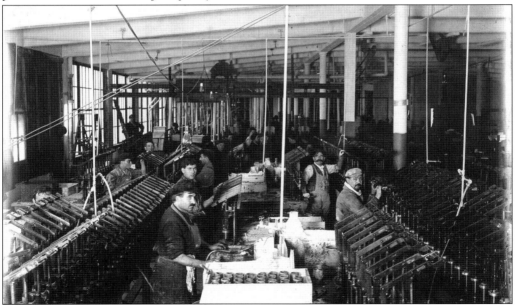

Blue Amberol manufacture is in full operation by the first week of 1915 in Building 24 on machinery that "went through the fire," as reported in the *Edison Herald*. Building 24 was badly damaged, but its floors, made of solid reinforced concrete, saved the machinery and permitted quick recovery and resumption of manufacturing.

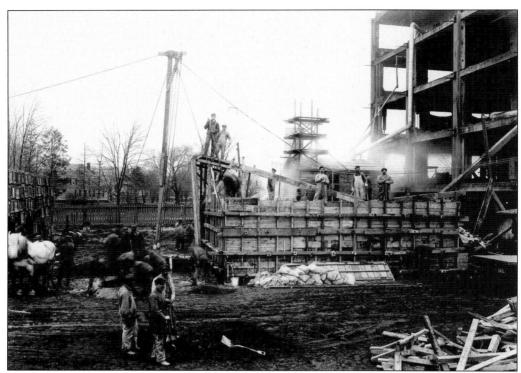

Vault 33, made of Edison Portland cement, was built to preserve master recordings in case of any more fires. This construction photograph was taken in early 1915.

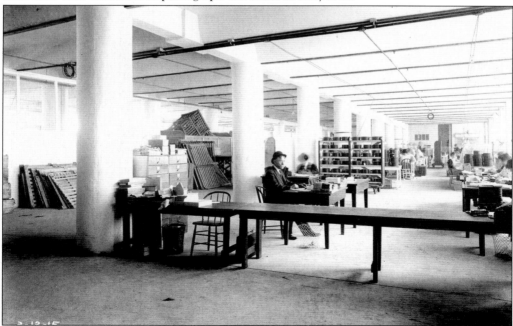

This is the third floor of Building 24, its columns and ceiling beams completely rebuilt by March 1915. Disc recordings are stacked on shelves in the distance, and work is returning to normal.

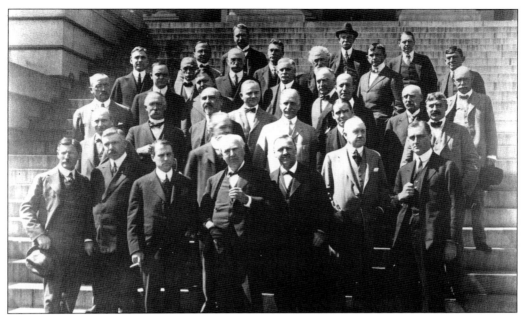

Edison served as president of the Naval Consulting Board, which evaluated military-related inventions from the public. The board gathers for its first meeting in Washington, D.C., on October 7, 1915. Navy secretary Josephus Daniels stands to the right of Thomas Edison, assistant secretary Franklin D. Roosevelt is at the far right. The inventor Peter Cooper Hewitt is behind Edison and to the left, and Leo Baekeland (inventor of Bakelite) is behind Hewitt and to the left.

At the National Preparedness Parade on May 13, 1916, Edison is joined by fellow board members Hudson Maxim, inventor of a machine gun (center), and William C. Saunders, a mining engineer. Mina Edison feared so for her husband's safety that she followed the entire parade route on the sidewalk from Washington Square to its end at Central Park, a distance of almost 50 city blocks.

The Edison industries were strong supporters of the war effort and conducted several Liberty Loan events in 1917 and 1918 to encourage employees to purchase stamps and certificates (to be redeemed later) that would defray costs. This photograph brings together several parades and rallies, plus a view of Thomas Edison himself filling out his coupon book.

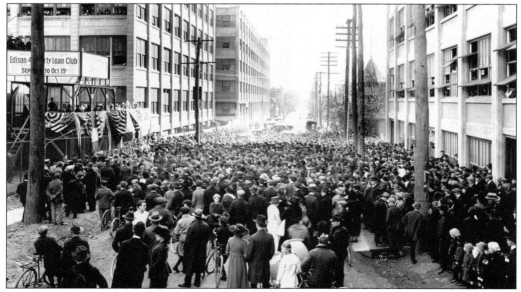

Employees gather on Lakeside Avenue for a Liberty Loan rally in 1918. These events featured songs from Edison recording artists and addresses by Charles Edison, other company executives, and visiting officers, American, British, and French.

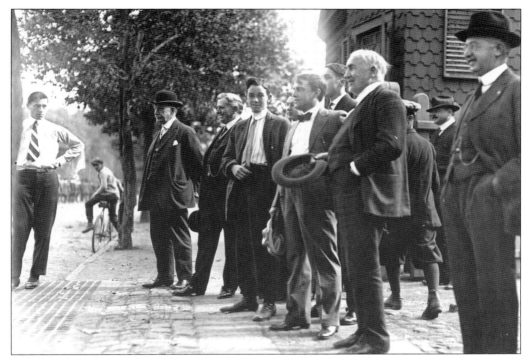

In September 1914, just after the outbreak of the First World War, Edison steps outside the main gate to review a parade on Main Street in which the Storage Battery Guards are marching. He is joined by Robert Bachman, storage battery executive (center, with hat in hand); Miller Reese Hutchison, chief engineer (with bow tie); and Walter Miller of the recording division, right.

The Laboratory Home Guards step outside Building 5 for a group portrait in 1917. William H. Meadowcroft, Edison's personal secretary (right) and Charles Edison stand alongside.

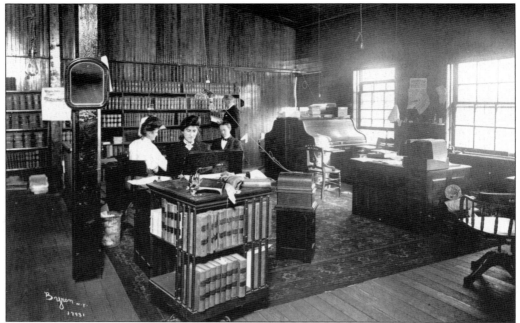

The legal department originated in 1903 with Frank L. Dyer as general counsel. The office was on the third floor of Building 5. Alexander Elliott, standing in the background, was counsel to Thomas Edison's ore milling company and the New Jersey and Pennsylvania Concentrating Works and later joined the legal department. He died just six months after this photograph was made in May 1904. Other staff members are, from left to right, Mina McArthur, Anna Klehm, and Delos Holden.

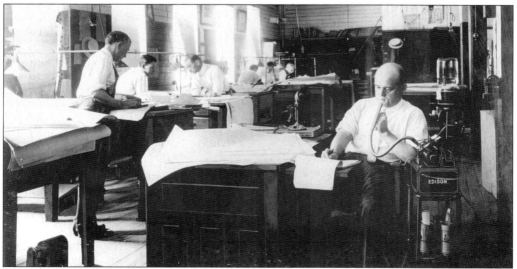

The engineering department was on the second floor of Building 5. Architects and draftsmen drew plans for models and blueprints for alterations in existing Edison products. The man at the right, his desk, and the Ediphone he is speaking into were added to the picture later, perhaps to make a print advertisement for an "engineering office" featuring the business phonograph. The busy engineers along the windows, however, are genuine.

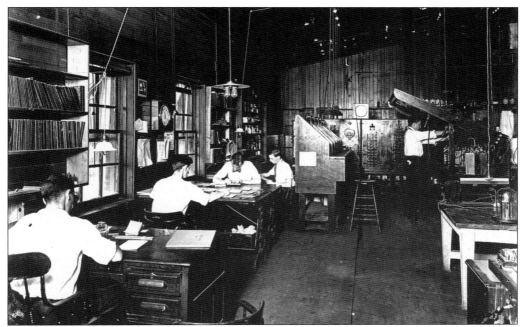

The drafting room staff is at work on the third floor of Building 5, around 1910. A supply of the uniform laboratory notebooks lines the shelves at the left. Over the decades, staff members filled over 4,000 notebooks with the records of tests and experiments. At the rear, a worker is testing storage battery cells.

Charles Edison takes a telephone call, around 1917. Charles began working for his father in 1913, becoming president of TAE, Inc., in 1926.

From left to right, Carl H. Wilson, Charles Edison, and Stephen B. Mambert stand in front of Building 5. Wilson joined the West Orange staff in 1898 with responsibility for phonograph sales. He rose to the position of vice president and general manager before departing in 1918. Following the divisional reorganization of 1915, Thomas Edison turned over many day-to-day responsibilities to his son Charles and Charles's assistant Mambert, who became "efficiency engineer" with added responsibility for financial matters too. (He may have also come up with the divisional plan.) In 1920, Edison responded to poor sales by conducting a draconian dismissal of factory and office workers. Mambert objected to the dismissal of so many office workers (especially accountants) and left too.

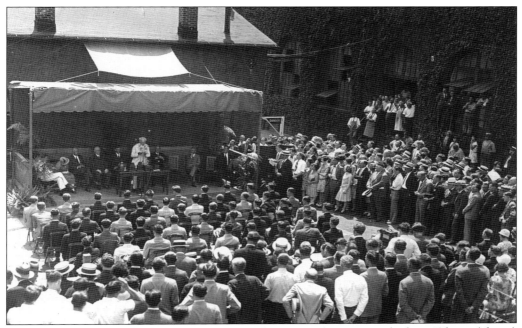

The 1929 Edison Scholarship Contest gets underway in the courtyard where Edison (above) and Charles Lindbergh, one of the judges (below), address the competitors, officials, and guests. The contest was ostensibly meant to find a bright young man to follow in Edison's footsteps, but it also generated valuable publicity for the upcoming golden anniversary of electric lighting and the new Edison Radio-Phonograph. Edison himself compiled the questionnaire that was administered to the 49 candidates who came to West Orange. The test went beyond math and science to test character, ambition, and general intelligence. The boys received round-trip train tickets and money for expenses, an Edison Radio-Phonograph, an Edicraft toaster, and copies of an Edison biography. They enjoyed lavish dinners, tours of the West Orange plant, and excursions to Coney Island and New York City, where they met Mayor Jimmy Walker. (Photograph above by Consolidated N. and A. Service; photograph below by Wide World.)

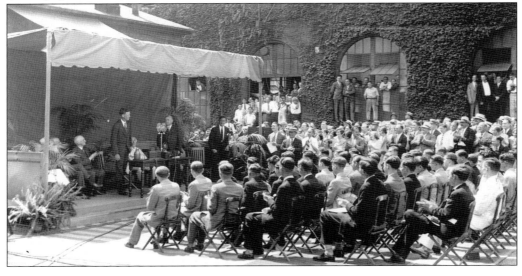

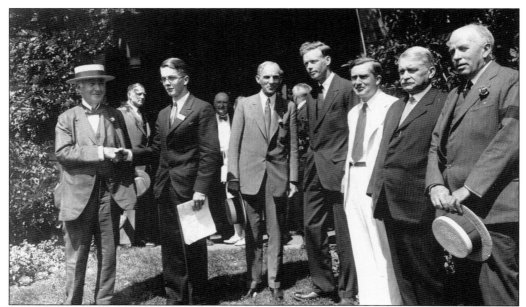

Thomas Edison congratulates the winner, Wilbur B. Huston of Seattle, Washington, who received a full scholarship to the Massachusetts Institute of Technology (MIT). Henry Ford (center) stands with Charles Lindbergh, Charles Edison, Samuel W. Stratton, president of MIT, and Lewis Perry, headmaster of Phillips Exeter Academy. (Photograph by Wide World.)

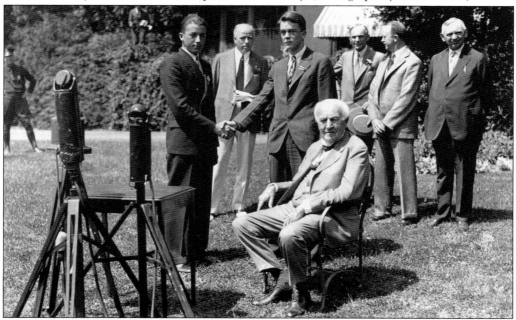

Arthur O. Williams (left), the winner of the 1930 Edison Scholarship Contest, receives congratulations from his predecessor, Huston. Ford and the judges stand in the rear. By 1930, public interest had dissipated, the transportation costs were $25,000, and business conditions were deteriorating as the Depression grew worse. Edison's health was failing by 1931, and no more contests were held. (Photograph by Handy and Boesser.)

In his later years, Edison received public tributes for his many achievements. Here at a Menlo Park ceremony in 1925 (sponsored by the Edison Pioneers), he reads a plaque commemorating the work he and his muckers did there. The photograph of the Edison home in chapter 1 has a circle that indicates the location of this stone. (Photograph by Fotograms.)

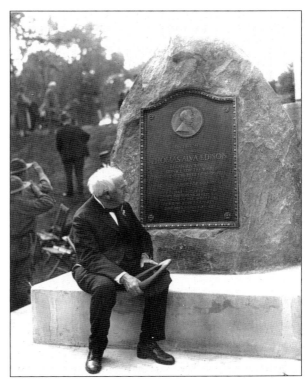

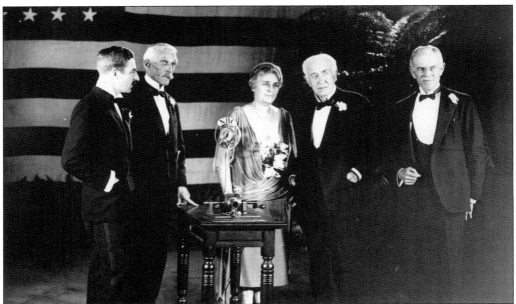

Treasury secretary Andrew W. Mellon (second from left) presents Edison with a Congressional Gold Medal on October 20, 1928. Also attending were Mina Edison and John G. Hibben (right), president of Princeton University. Ronald Campbell (left), the British *chargé d'affaires*, is present to return the original tinfoil phonograph on the table, which had been in the Science Museum in London since the 1880s.

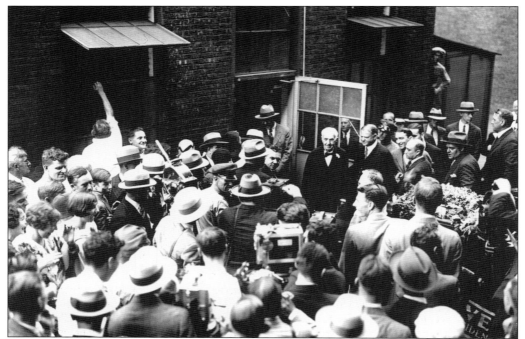

"Hoover Day," September 17, 1928, featured a visit from Pres. Herbert Hoover. Here he and Thomas Edison greet reporters and photographers outside the chemistry laboratory, Building 2.

Beginning in 1916, Edison periodically took camping trips with his friends Henry Ford, Harvey Firestone and his son Harvey Jr., and the naturalist John Burroughs. This image is from a trip in 1921. Mina Edison and her husband face the camera at the left; Ford faces the camera fifth from the right. Pres. Warren G. Harding is at the center. (Photograph by Harris and Ewing.)

Nine

GLENMONT

With the death of Mary Stilwell Edison in 1884, the inventor was a widower with three children. The following year, friends introduced him to Mina Miller, the daughter of Lewis Miller of Akron. He was an inventor and manufacturer of farm machinery and a cofounder of the Chautauqua Institution, originally a church-based, later a more general, adult education movement. Edison gave Mina the choice of a house in Manhattan or the New Jersey suburbs. She chose the latter, thus helping to determine the location of Edison's new laboratory.

Following their 1886 wedding trip to Fort Myers, Florida, where Edison had bought property the year before, the couple moved to Llewellyn Park, the nation's first private residential community, established in West Orange in the 1850s. The centerpiece of Glenmont, their 15-acre estate in the park, was a 29-room Victorian mansion built in the Queen Anne Revival style by the architect Henry Hudson Holly. At the bottom of the hill, just beyond the park gates, Edison built his new laboratory.

The couple had two sons and a daughter of their own: Madeleine (born in 1888), Charles (1890), and Theodore (1898). The children of the first marriage were initially off at private schools and later played only a minor role in life at Glenmont.

Mina (pronounced MY-na) took her responsibilities as a "home executive" seriously and made Glenmont an attractive home for her young family and a hospitable stopping place for distinguished guests, including Henry Ford, Harvey Firestone, Orville Wright, Charles Lindbergh, Andrew Mellon, Helen Keller, the king and queen of Siam, and the crown prince of Sweden.

Edison himself worked long hours at the laboratory and did not always return home for dinner. Even when on hand for meals, he would often retire from the table to a nearby rocking chair while the others finished eating.

Following Edison's death in 1931, Mina remained at Glenmont, cultivating her varied interests, the chautauqua movement, public recreation, bird-watching, and the Daughters of the American Revolution (DAR). She married a childhood friend, Edward Everett Hughes, in 1935; he died five years later. Mina lived to celebrate the centenary of Edison's birth and died on August 24, 1947.

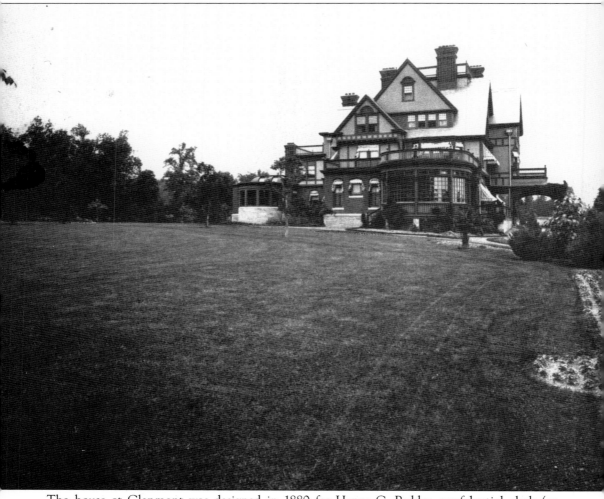

The house at Glenmont was designed in 1880 for Henry C. Pedder, confidential clerk (or accountant) for Arnold, Constable and Company, a New York City department store. Unfortunately, Pedder had embezzled the money to buy the land and build the house (as well as an addition). His employers ultimately took possession. They sold the estate to Thomas Edison

in 1885 for $235,000, a little over half its value. Pedder disappeared, perhaps to the West Indies. Edison once said of Glenmont "It's far too good for me but not half good enough for my little bride." This view, facing roughly south, is from about 1886.

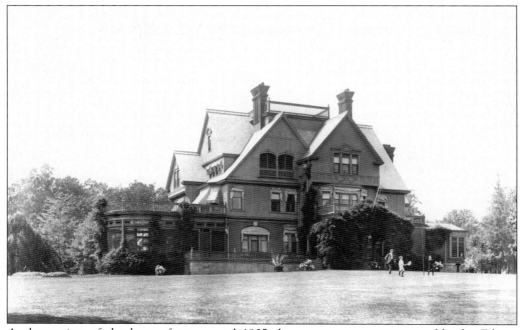

A closer view of the house from around 1905 shows some youngsters, possibly the Edison children, playing on the front lawn.

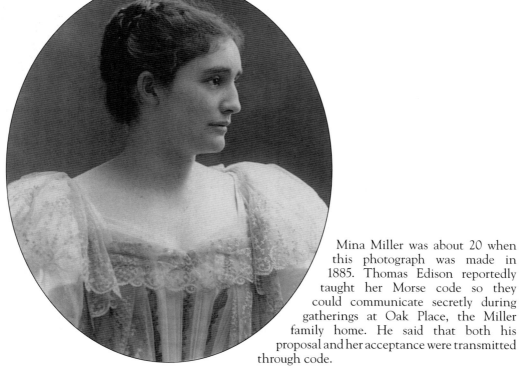

Mina Miller was about 20 when this photograph was made in 1885. Thomas Edison reportedly taught her Morse code so they could communicate secretly during gatherings at Oak Place, the Miller family home. He said that both his proposal and her acceptance were transmitted through code.

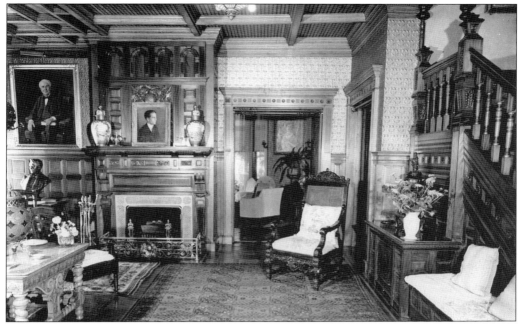

Visitors to Glenmont would be welcomed in the entrance hall, which was paneled in oak. Rising suns, a popular motif of the period, decorated the paneling. Portraits of Edison and his youngest son, Theodore, are visible to the left. A portrait of Madeleine Edison is just visible on the wall of the reception room in the distance. This photograph was taken just four days after the death of Mina in August 1947. (Photograph by George Van.)

The second-floor landing highlights the painting *The Morning After the Ball* by Abraham Archibald Anderson, an artist who lived in nearby Montclair. Edison found the painting, however, on display in Paris when he went there for the 1889 exposition. The stained-glass window at the right is of Penelope anticipating the return of Ulysses from the Trojan War. Ironically, it echoed Mina's waiting for her husband after long days and nights at the laboratory. (Photograph by Ralph and Ralph.)

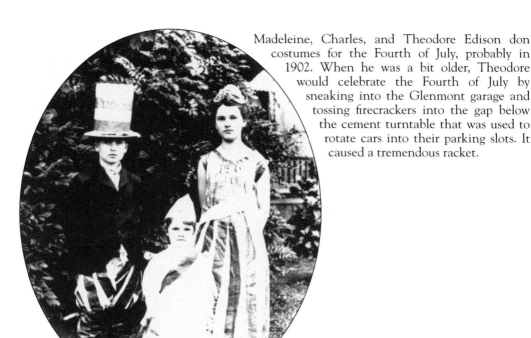

Madeleine, Charles, and Theodore Edison don costumes for the Fourth of July, probably in 1902. When he was a bit older, Theodore would celebrate the Fourth of July by sneaking into the Glenmont garage and tossing firecrackers into the gap below the cement turntable that was used to rotate cars into their parking slots. It caused a tremendous racket.

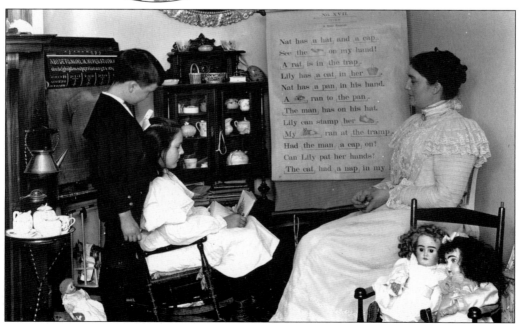

Mina Edison supervises lessons for Madeleine and Charles around 1900; two-year-old Theodore was probably in the nursery. The children attended local private schools. Later Madeleine spent two years at Bryn Mawr, Charles attended MIT but left without his degree to begin working for his father, and Theodore graduated from MIT with honors.

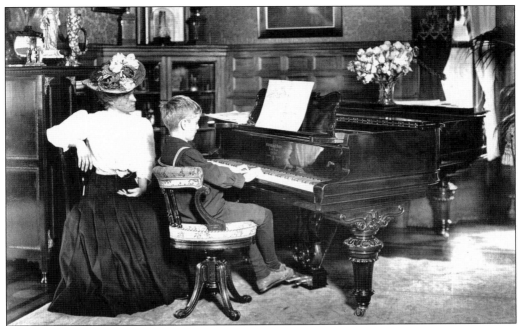

Theodore, about nine years old in 1907, takes his piano lesson in the den under the watchful eye of Lucy Bogue, who gave music instruction to all three children. She later became the secretary and companion of Mina and moved to Glenmont around 1930.

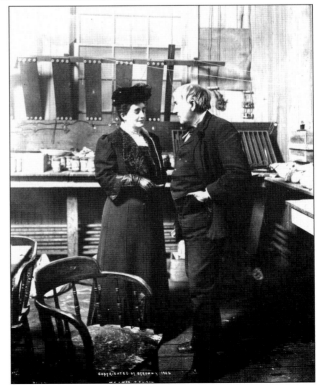

Mina and Thomas stand in the chemistry laboratory in 1906. Unlike Mary Stilwell Edison, who showed little interest in her husband's work, Mina had a good understanding of his projects. She even took notes of filament experiments at the Edison lamp factory.

Formal and informal moments are seen here in these two shots of Madeleine Edison's wedding to John Sloane on the Glenmont grounds on June 17, 1914. Sloane, an inventor, aviator, and airplane manufacturer, and his new bride later lived in New York City and had four sons, the only grandchildren from among Thomas Edison's six children. Charles married Carolyn Hawkins in 1918, and Theodore married Anna Maria Osterhout in 1925. Both sons eventually owned homes in Llewellyn Park.

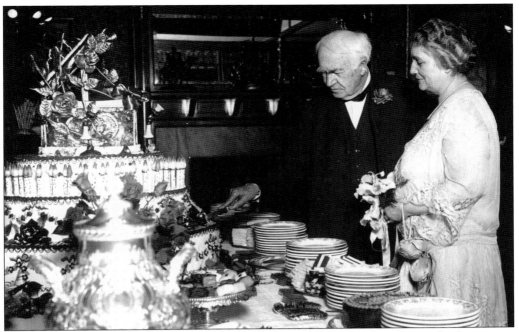

Edison cuts his 80th birthday cake at Glenmont as Mina Edison watches. During his later years, Edison was known for sitting down with reporters for an annual interview to be published on or near his birthday; he would hold forth on a variety of subjects.

The binoculars suggest that this group is bird-watching. Mina, in the white dress, was an avid bird-watcher. Over the years, she had numerous birdhouses and birdbaths installed on the Glenmont grounds. She later served on the board of directors of the National Audubon Society. This photograph is from 1937.

Arrayed in costume, Mina Edison (standing, center) and members of the Essex County Chapter of DAR gather for a meeting in 1912. In the following decade, she served as regent of the chapter and as chaplain general of the national DAR.

Mina (lower right) does a folk dance with others attending the National Recreation Congress in Atlantic City in October 1922. Mina was an advocate of parks and park-building, an interest perhaps fostered by her early experiences at the Chautauqua Institution in western New York State.

Ten

THE EDISON LEGACY

An astute guardian of his public image, Thomas Edison also had a firm understanding of his place in history and began managing his legacy long before his death. Following the move to West Orange in 1887, he carefully preserved the records of his Menlo Park years and eventually built a vault to house them. In 1928, needing to organize the mountain of business records accumulated over the decades, he established a historical research department not only to manage his papers but also to respond to questions from the press and the public about his work.

Edison died at home on October 18, 1931, following some months of failing health. The outpouring of tributes was tremendous, from scientists, statesmen, businessmen, the public, and the surviving muckers of the early days. The lines of visitors calling to view his coffin at the laboratory extended down the courtyard and onto Lakeside Avenue. He was buried at Rosedale Cemetery, only a few blocks away; Mina Edison was buried next to him following her death in 1947. (Both were reinterred on the Glenmont grounds in 1962.)

Operations at the laboratory gradually wound down over the next few years. The surrounding factories (most of which had their own small laboratories and workshops anyway) continued producing Voicewriters and batteries for another 30 years, adding some electronic and precision measuring devices to their product line in the 1950s. In 1957, the McGraw Electric Company took over TAE, Inc., becoming the McGraw-Edison Company. In 1985, Cooper Industries of Houston purchased McGraw-Edison Company.

Within a month of Edison's death, the family and the company established the Thomas A. Edison Foundation to promote his achievements, initially by supporting a scholarship fund and the construction of memorials. But the foundation's major accomplishment was the opening of the West Orange laboratory as a museum on February 11, 1948 (the inventor's 101st birthday). The Thomas A. Edison Foundation maintained the site until 1954, when it, the family, and the company began transferring ownership to the National Park Service, which today operates the laboratory and the home as Edison National Historic Site.

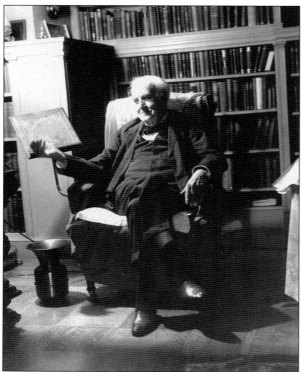

Thomas Edison had been diagnosed with diabetes in the 1890s and had controlled it through diet over the years. His last illness, perhaps complications of diabetes combined with stomach complaints and kidney failure, prolonged his winter trip in Fort Myers until June 1931. This is one of the last photographs taken of him, in the family library on the second floor at Glenmont on June 27.

Edison's coffin was on view in the library. On October 21, 1931, Pres. Herbert Hoover, Henry Ford, and Harvey Firestone, the rubber and tire magnate, joined Mina Edison and family members at Glenmont to listen to a radio broadcast commemorating the inventor. (Photograph by Charles James Fox.)

Press and newsreel photographers gather outside Building 5 on October 19 to record visitors as they enter to view the coffin.

On October 20, the crowds awaiting admission to the laboratory filled Lakeside Avenue.

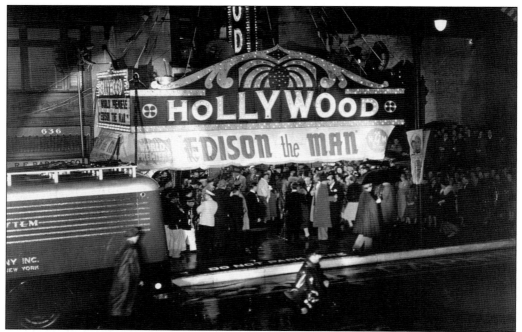

By 1940, the movie studios decided to pay tribute to the inventor of the film industry. This is the world premiere of *Edison the Man*, an MGM production starring Spencer Tracy, at the Hollywood Theater in Orange in May 1940.

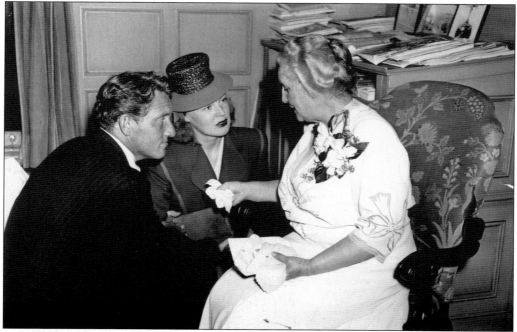

Spencer Tracy and Rita Johnson, who played Thomas Edison and Mary Stilwell in the film, meet Mina Edison at Glenmont. A second film, *Young Tom Edison*, starring Mickey Rooney as the (highly fictionalized) boy inventor, opened the same year. (Photograph by Handy and Boesser.)

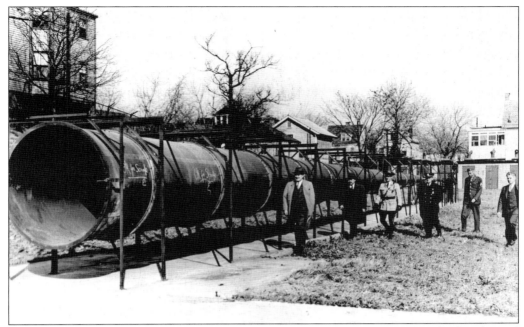

In November 1942, Charles Edison, governor of New Jersey from 1941 to 1944, leads aides and company officials on a walk along the 125-foot experimental recording horn, a remnant of the demolished Columbia Street studio, a block from the laboratory. The chalked message, "OK for scrap," indicates the horn will contribute to the war effort.

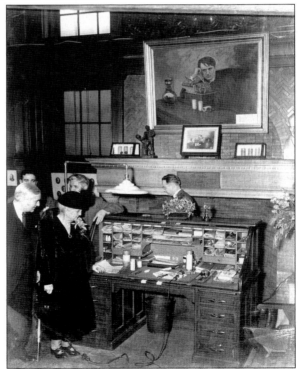

Charles and Mina Edison officiated at the ceremonial reopening of Edison's desk on February 8, 1947, only a few days short of the inventor's 100th birthday. The event was part of an ongoing plan to open the laboratory buildings as a museum.

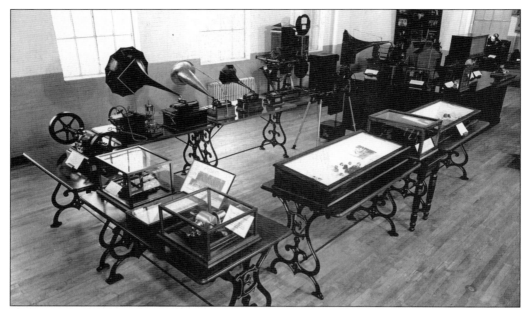

Phonographs and kinetoscopes, once turned out on the Edison assembly lines, have become museum pieces in the exhibition room of Building 1. In the 1890s, this space had housed brick worktables that stabilized delicate measuring devices. In 1950, the new display cases rest atop tables marked with the distinctive "E" that had been common throughout the labs in Thomas Edison's day.

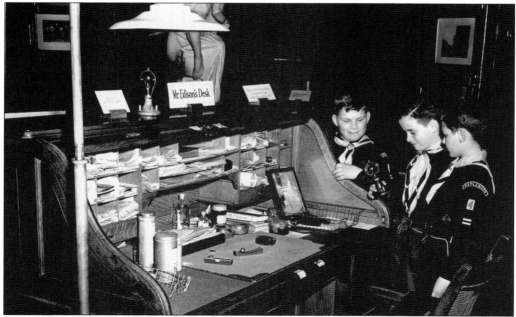

Three Cub Scouts from Troop 4 in Maplewood take a moment during their April 1954 tour to examine a replica of the first lightbulb on Edison's desk. The boys are identified on the back of the photograph. They are, from left to right, Michael Altman, Robert Cunningham, and Douglas Thompson.

Adolph Zukor, former head of Paramount Pictures and a film pioneer whose career stretched back to 1903, speaks at the dedication of a replica of the Black Maria on September 22, 1954. Harold G. Bowen, representing the Thomas A. Edison Foundation, sits at the right.

A reception desk and gift shop stood just outside the library in this November 1960 photograph. At the center is Norman R. Speiden, who began his career working for Edison's historic research department and later TAE, Inc. He stayed on into the National Park Service years, eventually becoming chief curator for the site. He can be seen earlier in this chapter with Charles Edison and the recording horn and at the reopening of Edison's desk.

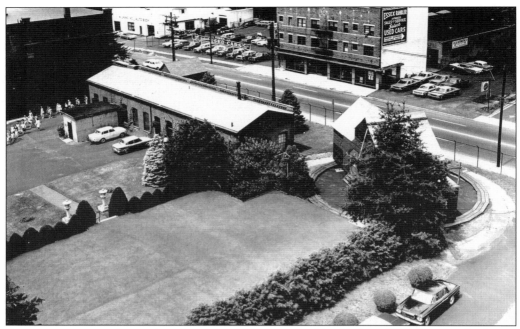

A tour group weaves its way into the center of the courtyard in this June 1967 photograph. Across Main Street, the Essex Rambler building eventually disappeared, but the Lucas Automotive garage behind it is now the maintenance building for Edison National Historic Site. Today the laboratory unit of the site, composed of the five original brick buildings, four cement vaults, the Black Maria replica, and some smaller structures, has shrunk almost to its original 1887 size.

Building 22 had survived the 1914 fire while multistory concrete buildings were consumed nearby. The unharmed disc-making machinery located here permitted the quick resumption of disc manufacturing. In the 1930s and 1940s, this area was used for fabricating advertising displays for the Edison Voicewriter. At the time of this photograph in January 1973, the building holds only debris and empty packing cases.

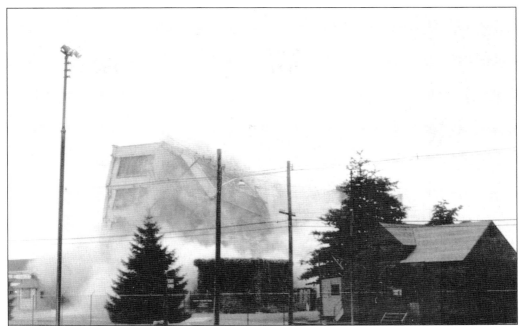

Building 24 had been one of the last of the many phonograph buildings. Badly damaged after the 1914 fire, it was repaired and became once again the starting place for tens of thousands of phonograph recordings. In the photograph above, it falls at last to the wreckers as part of an urban renewal project in 1974. Vault 33 and the Black Maria replica are visible in the foreground. Below, the remains of Building 24 reveal an A&P across Alden Street at the south end of the laboratory site. On Lakeside Avenue, a block north of this view, the Edison Storage Battery building is today privately owned and houses several small business; it is the only factory building from Edison's day still standing.

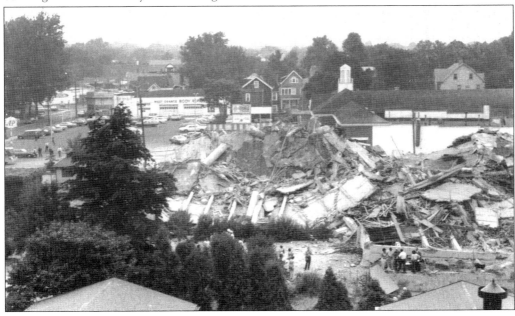

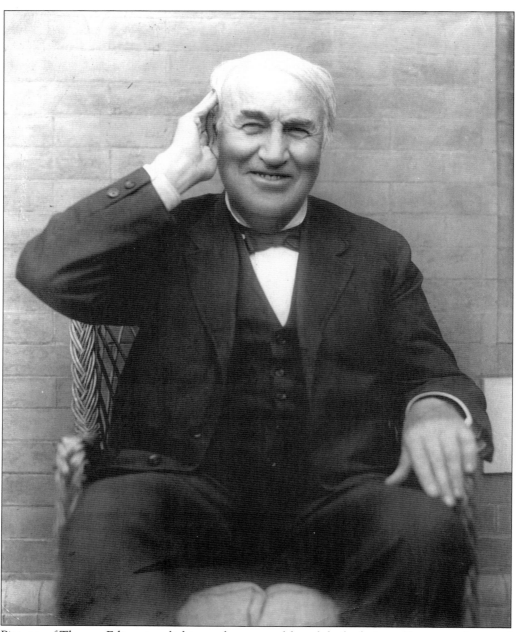

Pictures of Thomas Edison in a light mood are rare, although he had wit and humor and enjoyed jokes. In this August 1916 image, he smiles for the camera and raises his hand to his ear in a familiar gesture, perhaps to catch what his photographer is saying.

BIBLIOGRAPHY

Baldwin, Neil. *Edison: Inventing the Century*. New York: Hyperion, 1995.

DeGraaf, Leonard. *Historic Photos of Thomas Edison*. Nashville: Turner Publishing Company, 2008.

Frost, Lawrence A. *Thomas Alva Edison: The Man Who Illuminated the World, A Pictorial Biography*. Mattituck, New York: Amereon House, 1996.

Israel, Paul. *Edison: A Life of Invention*. New York: John Wiley, 1998.

Jenkins, Reese V., et al. *The Papers of Thomas A. Edison*. 5 vols. Baltimore: Johns Hopkins University Press, 1989–2004.

Josephson, Matthew. *Edison: A Biography*. New York: McGraw-Hill, 1959.

Millard, A. J. *Edison and the Business of Invention*. Baltimore: Johns Hopkins University Press, 1990.

Stross, Randall E. *The Wizard of Menlo Park: How Thomas Alva Edison Invented the Modern World*. New York: Crown, 2007.

ACROSS AMERICA, PEOPLE ARE DISCOVERING SOMETHING WONDERFUL. *THEIR HERITAGE.*

Arcadia Publishing is the leading local history publisher in the United States. With more than 3,000 titles in print and hundreds of new titles released every year, Arcadia has extensive specialized experience chronicling the history of communities and celebrating America's hidden stories, bringing to life the people, places, and events from the past. To discover the history of other communities across the nation, please visit:

www.arcadiapublishing.com

Customized search tools allow you to find regional history books about the town where you grew up, the cities where your friends and family live, the town where your parents met, or even that retirement spot you've been dreaming about.